Painting Flowers & Gardens

in watercolour and pastel

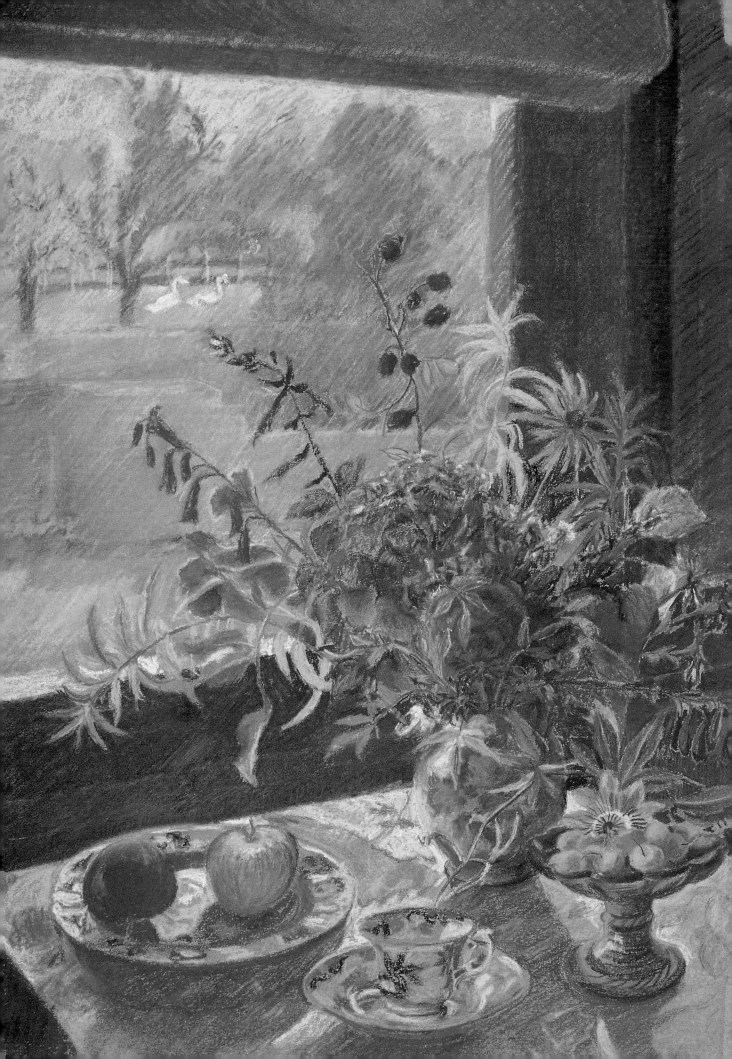

Painting Flowers & Gardens

in watercolour and pastel

ALISON HOBLYN

David & Charles

In memory of my father

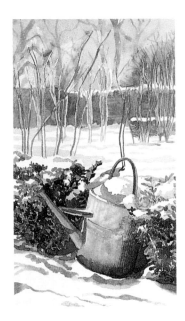

A DAVID & CHARLES BOOK

First published in the UK in 1997

ISBN 0 7153 0349 X

Book design by Diana Knapp
and printed and bound in Italy by Lego SpA
for David & Charles
Brunel House Newton Abbot Devon

CONTENTS

INTRODUCTION

The wonderful thing about painting flowers and gardens is how accessible these subjects are. In every season you will find something to paint. Beautiful subject matter provides a good start, but I hope this book shows that a knowledge of composition, tone and colour allows you to produce interesting and evocative watercolours and pastels from the humblest subject. Each medium is quite different, and you will find that at least one will suit your way of working. And by knowing the limitations and potential of your chosen media you will be able to make the most of your subject.

This book is a practical handbook. It aims to give you an insight into materials and techniques, and I have also tried to show you my personal approach to subjects. However, it should be emphasized that there are no 'right' or 'wrong' ways to go about things, and my way is really no better than another – it is just *my* way. Knowledge of different techniques gives more choice but these can be abandoned if they don't suit your personality. What I most wish to do is inspire you to go out and *paint*.

How often have you taken a photograph of a marvellous garden only to find that it didn't quite capture the feelings you experienced at the time? A camera fixes an image in certain ways: the colours are those allowed by chemical processes, the format is rectangular and the paper of limited texture. Photographs might record what you see, but whereas photography is rather like prose in a manual, painting is more akin to poetry: the poem may not give a precise description but it conveys a range of senses beyond the purely objective.

With a few painting techniques at your disposal you have control over the end result. You can produce a unique vision by heightening colours, subduing tones, highlighting areas of interest and generally manipulating 'reality'. This *personal* view is very important if you are to create a painting that is not pseudo-photographic: as Zola put it, art is a 'corner of Nature seen through a temperament'.

PAINTING GARDENS

Painters and gardeners have a lot in common because both create a concrete reality which evolves from a mere idea. Gardeners start by visualizing drifts of flowers in their plots: artists imagine the light seen through the leaves of the tree captured on paper. The next step is to

bridge the gap between the idea and the end result by employing a range of techniques. It's not always straightforward: the gardener faces problems with pests and frosts; the painter struggles with changing light conditions and the limitations of materials. During those difficult times when struggling to transfer vision to paper, every painter stops and asks 'Why am I doing this?' and I think the only answer should be 'Because nobody else can'. No matter how far short of expectations your work falls, only you could have done it – it's your creation. (And next time you'll produce something even better!)

The subjects available to paint in a garden are endless: there are combinations of plants and buildings or other 'hard-landscaped' areas; the play of light on foliage and lawns is always interesting, as is the mix of colour and form in the flower border. The paintings in this book will give you some idea of the wealth of subject matter available. *How* you choose to paint your subject is probably just as important as *what* you choose. Gardens come in many guises: those on a domestic scale are comfortable havens where human beings meet a generally benign Nature. They might inspire a cosy rendition of a humble subject such as a flowerpot or watering can. An

A SEAT IN THE SHADE
Watercolour, 12x19½in (30x50cm)
The feeling of shade in this picture is conveyed by the contrast between the darker tonal values of the seat and the bright values of the light filtering through the leaves of the tree.

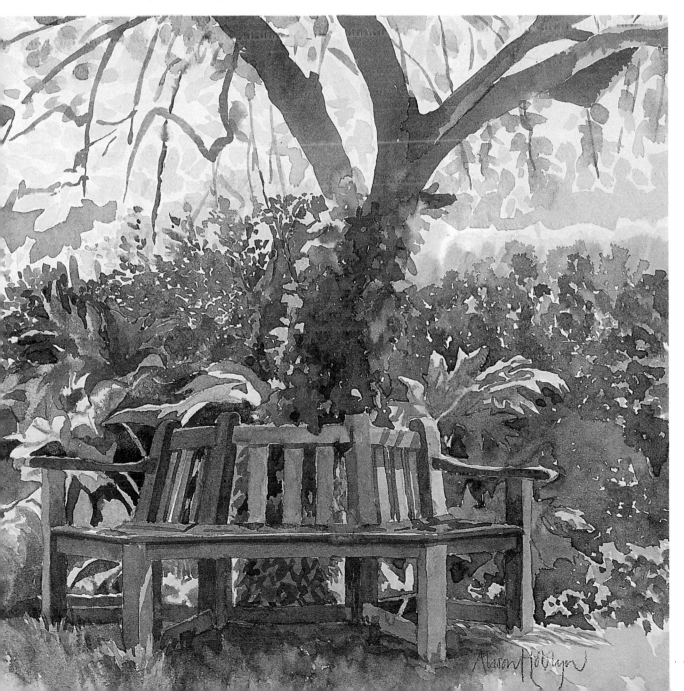

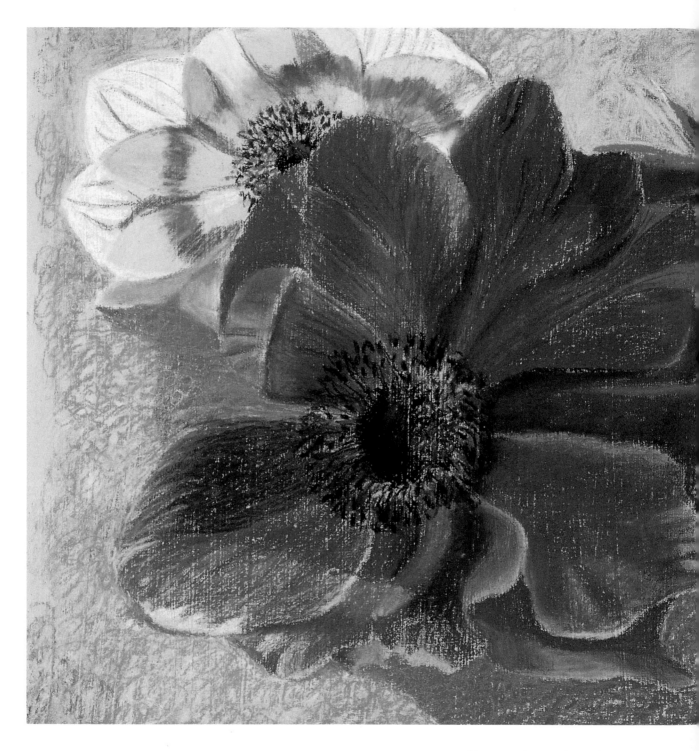

ANEMONES
Pastel, 18x24in (46x61cm)
These flowers have been scaled up to about five times their size and the light and shade acutely observed to produce a strong sculptural end result. The painter Georgia O'Keefe often painted flowers on a much larger scale.

awe-inspiring country house garden might lead you to imagine the elegant living that went on there, perhaps inspiring a nostalgic view of architectural vistas.

If you have your own garden the subject matter is readily available and you will know it in every light and season. If you don't, you can paint in public gardens and parks, and special permission is seldom needed. Ask keen gardeners to allow you into their gardens; they are often flattered by an artist seeking to paint their creation.

There is nothing better than gathering a huge bunch of flowers from the garden and then painting them as quickly as possible to capture the true freshness of growth. Colour has a very positive effect upon my day and always lifts my spirits. Chueh Yin, a Buddhist monk of the Yuan period, 1279–1368, also linked his mood with his flower painting.

When the emotions are strong and one feels pent up one should paint bamboo; in a light mood one should paint the orchid, for the leaves of the orchid grow as though they were flying or fluttering, the buds open joyfully, and the mood is indeed a happy one.

Art and Illusion, E.H. Gombrich

Flowers may seem an obvious choice for the painter because they are so decorative, but they are also potent symbols in our lives. We use them to mark birth, marriage, death, anniversaries and love. While botanists have meticulously recorded them in scientific illustrations, painters in every century have used flowers to convey ideas. In medieval times, because of their ability for growth and renewal, plants were viewed as prototypes of the divine. Each plant had a powerful symbolism, and they were often used to convey these meanings in paintings and sculpture. For example, in the Middle Ages the lily was frequently used as a token of purity and placed in the hands of female saints in art. Over the centuries, especially during the Renaissance, the Angel Gabriel has been painted bearing a spray of lilies as he brings to Mary the news of her divine child. The lily is also the sign of resurrection and to this day survives as such, being much in evidence at Easter throughout the world.

The pre-Raphaelites, painting in the mid- to late nineteenth century, were influenced by medieval ideology. They would often depict the lily alongside their perfect heroines and it was at this time that the 'Madonna lily' acquired its name. Sometimes they gave the subject a more naturalistic and earthy feeling: for example, in a painting by Dante Gabriel Rossetti (c1828–1882) of the Blessed Damozel, a madonna-like woman is depicted holding a spray of almost overblown lilies which echo her own ripe charms.

The twentieth-century painter Georgia O'Keefe (1887–1986) used to paint single lily heads – amongst other flower subjects – on huge canvases both to represent the universe in microcosm and, as she said, to give

PAINTING FLOWERS

In my early painting days I remember meeting another artist who was fresh out of college. Thinking that we could produce an interesting exchange of ideas, I asked her about her subject matter. Airily she said, 'Oh, I produce very large abstracts, I can't really say what they are about'. With disdain she continued, 'I certainly don't just paint flowers'. I retired, feeling chastened. Now, however, I would defend my subject matter to the hilt!

her viewers a chance to look really closely at a flower.

We all spend so much of our lives being busy and never truly looking that one of the best things to hear a student say is, 'I've never really seen it that way before'. It gives me great pleasure to watch people developing this new way of observing. There is no doubt that beginning to look hard at the subject you are painting and comparing your efforts with past and present painters can open up a new way of viewing everything you see.

A CONTINUAL INSPIRATION

Like flowers, gardens too have historically been of great interest to the painter. Each period has viewed them in different ways, not only because the skill of the painter improved to encompass new techniques (such as perspective) but because each time and culture had different ways of viewing the world.

The word 'pardes' occurs in the Old Testament to indicate a garden and came to be known as the Garden of Eden. The present-day garden stems from the Persian 'pairidaeza' which literally means enclosure. These 'paradises', with shady trees and cooling pools, were imported to Sicily by the Muslims and thence to Europe by the Normans. The European garden became an important part of medieval symbolism: a concrete example of humanity's attempts to come to terms with the powerful forces of nature. Many medieval manuscripts illustrate the gardens of the times, and they show clearly that an art based on symbolism rather than realism undoubtedly has a decorative quality. This may be one stylistic approach you might like to consider.

In China the great painters were also the foremost garden designers. Mountains and water figured strongly in Chinese landscape painting and the same (miniaturized) elements also showed up in garden design. An interesting feature is the way the subject matter was viewed by Chinese painters: it was almost always painted from a bird's eye perspective to show the 'divine viewpoint'. This just shows that whatever the ideology behind it, changing your view of a scene can give new life to your subject.

In England, too, painting and gardening intertwined. William Kent (1686–1748), a landscape architect of the eighteenth century, was responsible for a new approach to designing gardens. This was because he was also a painter and introduced painting concepts to garden design. For instance, he applied 'chiaroscuro', a painting term describing the manipulation of light against dark, to the way he planted trees. In seventeenth- and eighteenth-century

England, landscape gardeners were organizing and composing nature to suit their pleasure in much the same way that French *plein air* artists of the period were arranging it on canvas.

Throughout history both the designing and painting of gardens seem to demonstrate a need to harness nature and live with it peacefully. Even the wild gardens so fashionable today are generally kept carefully within bounds! One of the delights of a garden is how swiftly it changes.

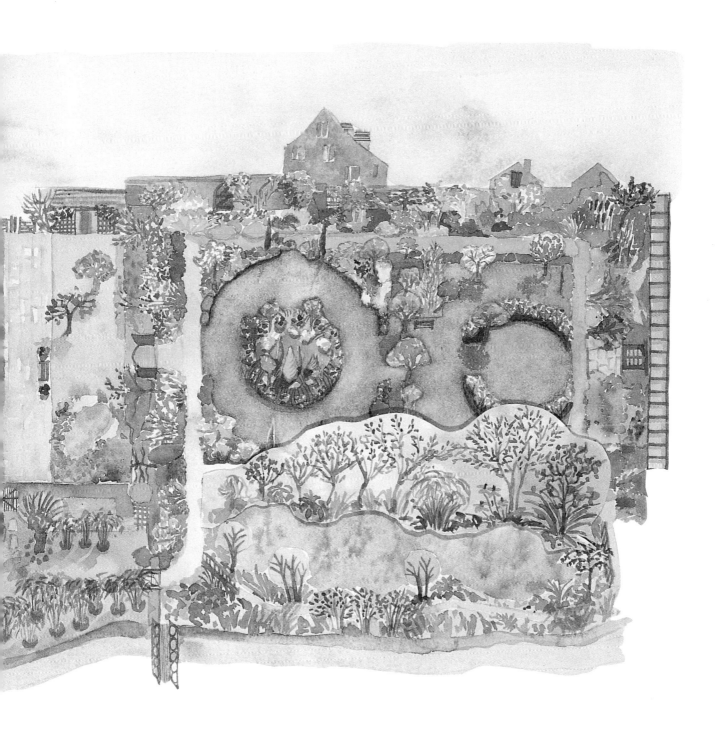

Morning and evening light can alter colours by its cool or warm cast, or change the appearance of form by creating different shadow patterns. Winter denudes plants – placing an emphasis on line – while summer foliage is interesting because of its mass. Claude Monet (1840–1926), that famous gardener and painter, is just one artist who has captured many aspects of the subject, at different times and in different lights. Creating a painting of a moment in the garden provides a little immortality!

A GARDEN PLAN
Watercolour, 13½x21in (34x53cm)
This painting draws some inspiration from the flat pattern approach of medieval painting. It manages to convey more information than a single perspective rendering whilst still being decorative. The clump of trees by the pond flaps open to show more detail underneath!

PREPARING

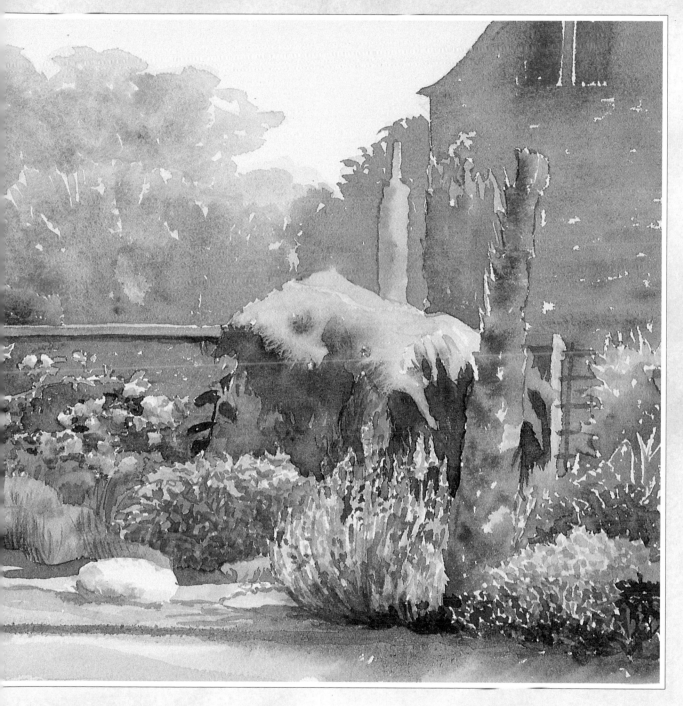

TO PAINT...

chapter one

DEVELOPING AN
APPROACH TO PAINTING

A garden provides an almost limitless range of subjects, but to produce a really strong image you must be clear about your intentions, about what you want to depict and about how you want to portray it. Look, for example, at the overall pattern formed by hard landscaping (walls, paths, pergolas) or hedges and trees. Or focus on the shapes, textures and colours – how many different greens can you record?

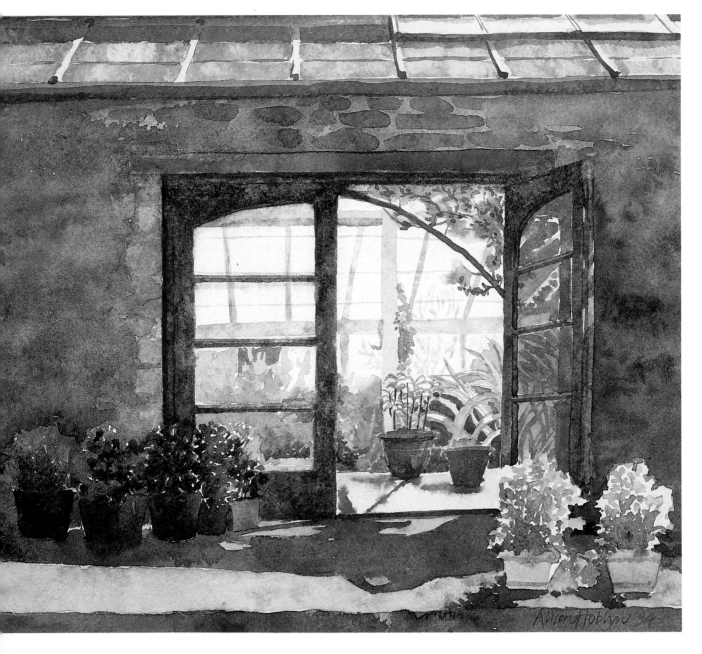

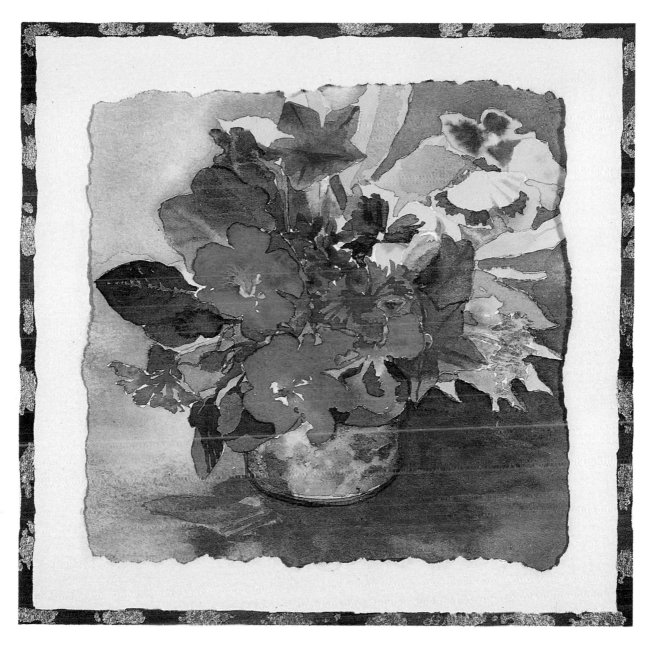

▲ *NASTURTIUMS AND PANSIES*
Watercolour and gold leaf, 10x10in (26x26cm)
This is about colour! Although I tried to convey the essence of the flowers, the painting became more like a patterned textile.

◀ *GLASSHOUSE IN SPRING*
Watercolour, 12x12in (30x30cm)
This painting is more about light than colour; the contrast between dark exterior walls and the bright glasshouse beyond helped me to convey the feeling of piercing light and sense of hope that arrives in early spring.

Plants that climb walls or overhang steps make interesting subjects, as do reflections in water. The list is endless.

Before you begin to paint, crystallize your ideas by asking yourself, 'What really interests me about the subject I have chosen?' Maybe you are attracted to the emotional aspect: is the palette subdued and cool, giving a melancholic tinge, or are the colours bright and warm, the light intense and the feeling joyful? Where is this light coming from and how does it change or accentuate the scene? Is it the strong sense of three dimensions that

(pages 12–13) DOVECOTE BORDER *Watercolour, 12x21in (30x54cm)*
This was a joy to paint over three early mornings. I had to discipline myself to leave the work as soon as changes in the light began to alter the shadows.

captured your imagination? Perhaps the subject is more suited to an almost textile-type interpretation, so that you want to paint the shadows on the grass because of their pattern. Whatever your inspiration, don't get side-tracked into putting in so much information that it detracts from your 'story'. (And this should be a story you are really bursting to tell!) One of the commonest failures in painting is trying to include too much. Like the person whose conversation rambles off the point, a painting without focus will fail to hold the attention.

One very useful piece of equipment which will help in this process of selecting your subject is a viewfinder made of paper – with its help you can make decisions about what to leave out of your composition and concentrate on the basic design of your painting. The balance of elements, tones and colours also needs to be considered. This is all described in Chapter 4.

Another important question is 'How much time do I have to complete my painting?' This will affect the complexity of your painting, and probably its size and the medium you will use. There is nothing more disappointing than biting off more than you can chew. So help yourself by simplifying your composition, and if you find it difficult to control your enthusiasm, at least have a sketchbook and camera at the ready to give you the necessary back-up.

A sketchbook is an invaluable tool for recording ideas quickly (see Chapter 4), especially when working from nature. When working outdoors the most obvious and fastest changes occur in the light. Even in fairly constant conditions, as a very rough guide, you will only have about two-and-a-half hours before the change in lighting alters your view.

SUIT THE MEDIUM TO THE SUBJECT

In this book I use watercolour and pastel: the obvious difference between them is that one is a wet medium and the other dry. Both are suited to working outdoors but very different effects can be achieved with each. Watercolour is a transparent or translucent medium whilst pastel is more opaque, and this means that areas of a pastel work can be overworked more easily.

You may have come across the expression 'pastel painting' as opposed to drawing. As a rough definition, drawing can be said to use line to express an idea, while painting is more about areas of colour or of tone. The most useful thing about pastel is the way that it straddles definitions. I really enjoy being able to use the medium in both a linear, draughtsmanlike way and in a more painterly fashion.

Watercolour is probably able to come up with more surprises. The fact that it flows easily and is not totally controllable means you can produce unexpected and exciting results.

The experiences of using pastel and watercolour are very different. Your choice of medium will develop as a personal response to what you see. For example, in my watercolour of *The dovecote border* (pages 12–13) I wanted to convey the morning light behind the wall and to put quite a lot of small detail into the flower border. If I had used broad strokes of pastel the plants would have been far more impressionistic – unless I had made the picture much larger. I also liked the area of white paper left untouched in the watercolour: it helped me convey the feeling of a fresh morning. I chose pastel for my drawing of *Pot by the dovecote* (pages 18–19) because the wonderful textures could all be expressed perfectly with pastel techniques. This is not to say that I could not have reversed the media – but having more techniques in my armoury gave me more choice.

Watercolour can be applied in very thin glazes or quite thickly. My personal preference, and interpretation of the word watercolour, is to use it transparently, mixed with quite a lot of water (or water and gum arabic). The secret of watercolour painting often lies in the timing; judging at what stage of dryness the next film of paint can be overlaid on the first. I enjoy working 'wet on wet' – applying paint to a wet or damp ground. The spread of the paint can be quite uncontrolled and so using this method successfully needs practice and courage. I would probably employ wet on wet on a subject that needs a looser approach, on a day when I am willing to be rather more free and easy.

Pastel generally does what it is told! Unlike fluid watercolour, it is physically more static at the point of contact with the paper. It is also easier than watercolour to remove once applied. Compare the detail of the watercolour *Daffodils* with the pastel of *The topiary*

DAFFODILS
Watercolour, 19x13in (50x35cm)
Daffodils mean spring and awakening to me. I wanted this painting to be lively so I used plenty of pattern in the foreground and made the flowers stand out against a background which includes violet, the complementary to yellow.

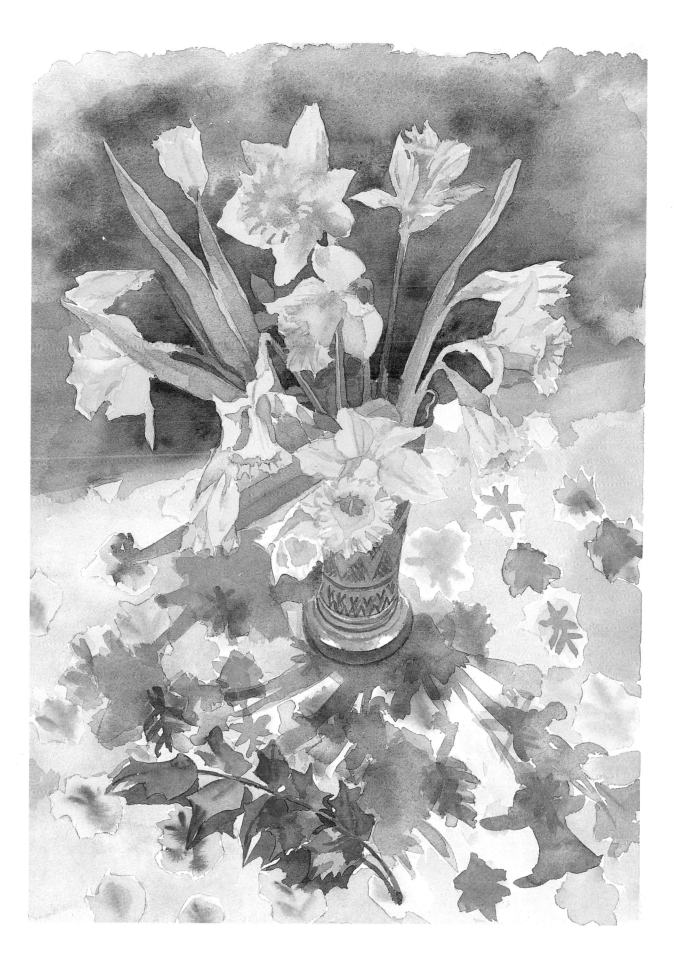

garden, dusk (pages 118–19). The latter is a formal, structured subject, and pastel gave me the solidity and control I wanted. The daffodils are loosely painted, and the translucent colour on white paper gave me the luminosity I saw in the first spring flowers. Watercolour to me is a medium which relies upon not painting an area to produce highlights. The paper, or support, is usually white and it is this, shining through the thinly glazed layers of paint, that produces the luminous effect in watercolour painting. Pastel, on the other hand, is usually applied to a toned support and the highlights are added with white or light-coloured pastel. Although essentially an opaque medium, it is possible to cover areas lightly so that the background shows through.

BE OPEN TO HAPPY ACCIDENTS

Once you have practised some of the techniques in this book you should have an insight into the different properties of watercolour and pastel. Techniques are there to help you get your ideas across, but as your skills develop you may begin to be too careful. *Don't play safe!* Just as a floating seed in a garden allows an unintentional burst of colour to appear in just the right place, so happy accidents can occur on paper. You need a free state of mind more than any technique, and really vibrant paintings result from being very slightly out of control of one's medium. As the Zen Buddhist advice goes, 'Develop an infallible technique and then place yourself at the mercy of inspiration'. Although it is easier said than done, don't try too hard, learn to enjoy experimentation and be prepared to discard a painting at any point. If you don't feel too attached to producing a finished work, you may be surprised at what you achieve.

POT BY THE DOVECOTE
Pastel, 23x19in (59x48cm)
White pastel has been used here for the highlights.
Although it is not at the centre of the composition, the pot is the major focal point because the eye is drawn to it by the curve of the path and because the light 'shoulder' of the pot contrasts with the dark wall behind.

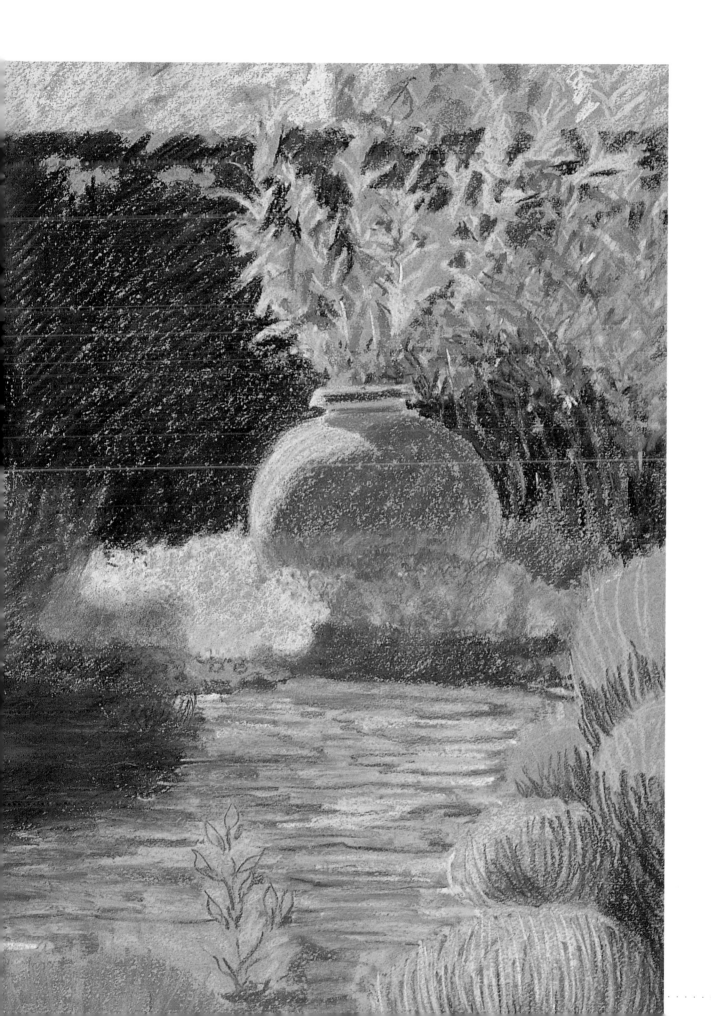

chapter two
WATERCOLOUR
PAINTING MATERIALS

PAINTS

Watercolour paint is basically a mixture of *pigment* – generally a coloured powder – and a binder – which is essentially *gum arabic* with a few other constituents. Pigments that occur naturally such as yellow ochre (a coloured earth) can be variable in quality, but good manufacturers such as Winsor & Newton choose those with the greatest purity, brilliance and stability. These standards are also maintained with chemically created pigments such as alizarin crimson – I'd always wondered about its exotic name until I found out that it originated from a coal tar called alizarin.

Some pigments, such as cadmium, have a degree of toxicity. Although manufacturers are prohibited by law from producing paints outside a safe standard, it is as well to observe sensible precautions, for example not licking your brush! Some colours are more permanent than others, and those that fade badly are called *fugitive*. All manufacturers have systems to rate permanence, but they are not necessarily the same, so one maker's best rating could be the equivalent of another's worst.

It is worthwhile buying artists' paints because of the quality of pigment, the choice of hues available and also because cheaper paints often contain fillers to extend the pigment so the colours don't remain as intense in a dilute wash.

Watercolours are produced in different sizes of *tubes* or *pans*. The formulations are slightly different: tube paints have softeners added to ease their flow, whilst pans often have extra glycerine to prevent them drying out because they are open to the air. Pans are slotted into a portable tin or box. They need quite a lot of water applied to them to enable the brush to lift up the pigment. Many artists pour water – warm if available – over the entire tin of colours to soften them before beginning to paint. This saves time, which is of the essence when using watercolour. You can top up pan colours with tube colours – these tubes look quite small, but I am always surprised by how long they last if I remember to screw the tops back on carefully.

I use both formats. Pans are very portable for sketching but unless clearly labelled or ordered in the tin it may be easy to dip into the wrong colour. Pans are my choice if I want to produce a quick on-the-spot colour sketch, or if I'm working on a fairly small scale and only need little amounts of colour. For larger work I favour tube colours, carefully arranged in dollops on a palette. With tube colour it is easy to mix up larger amounts of paint quickly, but when working outdoors the need to carry a decent-sized palette and several tubes becomes a problem. When you have finished a painting the remainder of the dollops can be left for the next one, but inevitably there is some wastage when you are washing the mixes off the palette. There is definitely less waste with pans.

The choice of colours is very personal but relatively few are needed because so many more can be achieved by mixing. For my suggestions on selecting a palette see Chapter 6.

An optional additive to basic watercolour paint is *body colour* which is added to make it opaque. It was used by the pre-Raphaelite painters, who added chinese white to make their colours more opaque and to create highlights in their paintings. Chinese white is still available but there is now white *gouache*, a denser modern alternative. Coloured gouache is an opaque water-based paint. The cheaper-quality gouache is pigment which has been made more opaque by adding a white extender and its colour brilliancy is thus reduced. High-quality gouache relies on very dense pigment to make it opaque and so its colour remains bright. In this book I am more concerned with using watercolour transparently and allowing the white paper to provide the highlights. Using paint in an opaque fashion is very different to manipulating transparent washes – pastel is the opaque medium in this book.

*CONSERVATORY AT
SPRING HILL
Watercolour and gouache,
14x9¼in (36x24cm)
This was painted in an
opaque fashion using
watercolour and gouache.
Only a few areas – such as
around the geranium heads
on the radiator – reveal
any background paper.*

ADDITIVES

Various additives can be mixed with watercolour to change the way it behaves. For example, the gum arabic which is used to bind the pigment particles together and help them adhere to the paper can be bought separately as a viscous liquid and added to the paint at the point of mixing it with water. Nowadays it is sold in small bottles in art shops – I remember it in huge canisters at a carpet design studio where I worked as a student. Each day a technician would freshly mix the dry pigment and gum together ready for us so-called creative types to use! And if her mixing was a little faulty we ended up with rather chalky paints that had a tendency to detach from the paper in powdery drifts.

I use gum arabic most in studio conditions – when working outdoors its viscosity can prove to be an efficient insect trap! Joking aside, I find I use it with care, because it makes the paint more soluble; this means that it is not as easy to paint over a wash that has added gum in it. Nevertheless, in spite of these drawbacks it imparts a particular quality to a painting which I really like. For examples of gum arabic in use, see pages 81–2.

Ox gall is another additive that can be diluted in the painting water. It modifies the surface tension of the

water and eases penetration of liquid into the paper, and you will find that the washes may 'rush' because of the improved flow. This can be useful on heavily surface-sized papers (see page 24) which are resistant to the wonderfully flowing nature of even very wet water-colour paint. However, I prefer to select a paper that gives me the right degree of absorbency.

Water is an additive which is very often overlooked. There are purists who insist on only distilled water. Very hard water can increase the granular nature of the more sedimentary pigments, so if you are aiming for an even coverage of the paper, using distilled water can reduce this effect. I have nothing momentous to add here, although I think it's fun to consider the particular water you are using. On my travels I have used water from a Moroccan cistern, the precious Scottish water beloved of whisky drinkers, and humble tap water. I do remember dipping a bottle into a well in the grounds of Mottisfont Abbey – only to be warned not to drink by a horrified onlooker who related tales of rats doing unsavoury things in it. Whatever its composition, it seemed to enhance the clear reds of the *Rosa mundi*!

When painting outdoors you need a good supply of water. I carry a large plastic bottle with me and change the painting water in my jam jar frequently: muddy water equals muddy colours.

MASKING FLUID

This is a latex liquid that is used to mask out areas which need to remain unpainted. It dries to a shiny, waterproof film and after it has served its purpose can be rubbed off with your finger. It can be applied to virgin paper or over previous colour, but with some papers or pigments you may have to be careful that it doesn't remove the surface underneath. Masking fluid is the ruin of many a young brush, so immediately after use I clean it well with white spirit, then water and washing-up liquid.

There are two colours of fluid available – white and pale yellow. Yellow masking fluid shows up the masked areas clearly but I find it misleading, because when painting you are constantly relating areas of colour and tone to each other and a whole area of yellow may temporarily upset the balance of colour. For this reason I prefer white fluid (on white paper) – although as my technique doesn't depend on putting down lots of large washes, I rarely use big areas of masking fluid.

PALETTES

Purists demand porcelain palettes for mixing their colours; they are lovely – smooth with just a hint of 'key' that helps mixing – but they are very heavy. I have a selection of good plastic palettes with small compartments around the edge for isolating little dabs of tube colour, and large inner mixing areas. One American palette has a lid with wells which can hold enough paint for large washes. This lidded palette can also be used as a box for the tubes. I have several palettes so that I do not have to clean each one if I am working on several paintings – I can just go back to the relevant palette with its idiosyncratic mixes. I probably like watercolour so much because cleaning up is not my strong suit and here is the perfect excuse to avoid it. If you don't want

to buy a palette immediately, large white china plates will do. You'll need one for each colour group or all your washes will converge into sludge.

Watercolour boxes for holding pan colours have small integral palettes. These are great for use 'in the field', and they suit me as I do not often want to mix up large one-colour washes. If I do need large washes I use a light plastic palette of the kind that looks like a tray for baking fairy cakes.

BRUSHES

Sable brushes are considered to be the finest for artists but there are excellent substitutes these days – I often use one which is a mix of sable and synthetic hairs. A brush can be an expensive purchase, although the cost is justified by the craftsmanship involved in their manufacture. Buying cheap artists' materials is a false economy: when you are struggling to master techniques you need to be able to rely on your equipment not to make things more difficult and thus dull your enthusiasm.

There are many brushes: round and flat, soft and hard. Those for watercolour are generally soft-haired, and I prefer round ones. If I had to restrict my purchase to one brush I would choose a large No. 14 round with a fine point. With practice this brush has great potential; the tip enables you to paint delicate lines while the rest of the hairs act as a generous reservoir for paint – enough for large washes. I find that its size prevents me from becoming too fussy and it is only occasionally that I augment with a No. 7 round. For very detailed work I might use a size 1 sable.

Look after the brush tip – if it remains bent in a pencil case or jam jar it will never straighten properly again. It's worth buying a canvas brush roll to carry brushes around in; failing that, I attach each of mine by its handle with masking tape into a loo-roll tube so it can't move about. Sometimes I dip the hairs into neat gum arabic before I store it, to provide a little extra protection. Rinse off the gum before the brush is used again.

DRAWING BOARD

Drawing boards can be bought from art suppliers but there is a cheaper alternative: buy a piece of marine ply at least 6mm (¼in) thick from any timber merchants. It should ideally be marine ply because you may need it for stretching wet paper, and it should be reasonably thick, as drying paper can warp a lightweight board. A useful and portable size is 460 x 610mm (18 x 24in). This will easily accommodate half a sheet of 'imperial' size paper or an A2 sheet (see page 24). It is also a size that you can easily prop on your lap without extra support when painting outdoors. The choice is up to you, but don't go too small as you need to expand your confidence, not give in to your self-doubts!

MISCELLANEA

Gummed paper strip is used to attach paper to a board when it is being stretched. You will also need a knife for cutting paper and slicing through the gummed tape to remove it from the board. Tissue is invaluable for blotting, removing pigment, catching runs, mopping up spills and cleaning brushes.

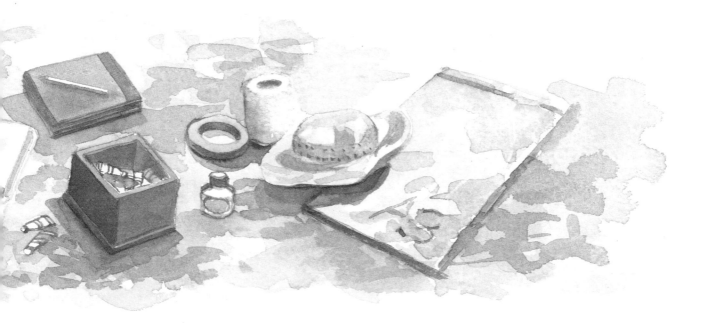

PAPER

Paper is the most usual 'support' or ground to which watercolour paint is applied and the array of papers available bewilders even the professional artist. From all this choice a favourite often emerges – the one I use often is Winsor & Newton's 140lb (300gsm) rough. It is always worth experimenting because one paper may be more sympathetic to a subject than another.

Paper is made from a wet pulp of fibres settled and dried in the form of a thin sheet. When magnified it looks like a complicated web, and it has a profile that shows peaks and troughs: it is these troughs which are receptive to the paint. Paper is naturally very absorbent. For watercolour painting this absorbency needs to be controlled by the addition of a size, a gelatinous substance which reduces water penetration into the paper. Most watercolour paper has size applied to its surface at the end of manufacture – something to remember when using masking fluid (see page 22) which may lift off this surface size as it is peeled away, leaving paper with a very different absorbency underneath. Some watercolour artists like to work on low-sized etching paper because this is more absorbent and can give the paint a pleasantly fuzzy appearance, not unlike painting on blotting paper. This type of paper is capable of producing some interesting soft effects suitable for distant vegetation or watery or misty scenes.

Handmade paper is produced by a labour-intensive process and as a result is expensive. *Mouldmade paper* uses the same materials but is made on a machine which reproduces the qualities of the handmade as closely as possible. Most of the papers you find in art shops are mouldmade. Most art papers are described as acid-free – that is, they don't contain destructive substances likely to reduce the life of the paper.

Successful watercolour painting depends a lot on light reflecting back through translucent washes from the surface of the support. The most reflective colour is white, and when painting I try to preserve white areas as long as I can. Some watercolour papers do have slight tints, and it is possible to paint on coloured pastel papers if they are stretched first.

Paper is sold in bound pads and individual sheets. Pads tend to be produced in metric sizes. Metric dimensions are very logical. The most popular range of sizes is from A1 to A6; A1 is 594 x 841mm (23 x 33in); A2 is half an A1 sheet; A3 half an A2 sheet and so on. For individual sheets of handmade or mouldmade paper you will find that the commonest size is the old British 'imperial': 762 x 559m (30 x 22in). Other countries have their own traditional sizes. Although standardization through metrication approaches, artists are still able to experience national and historical differences through a simple sheet of paper! All papers have different

LOW-SIZED PAPER

This is painted on my own handmade paper, which is quite absorbent and has a slight pink tint.

ROUGH PAPER

This is a Whatman 140lb (300gsm) paper; it shows up the pooling pigment and dry brush strokes well.

weights generally expressed in gsm (grammes per square metre) or lbs (pounds per 500 sheets of a particular size). For watercolour painting the lighter papers first need to be stretched (see pages 26–7) to prevent permanent buckling after wet paint is applied.

Surface texture is an important aspect of paper selection. Three things produce texture on a sheet of paper: the fibres used in its manufacture; the way it is dried; and the imprinting of a pattern onto its surface during manufacture. Paper texture is generally classified as rough, Not or hot pressed (HP).

Rough describes the natural surface of a handmade sheet of paper which has been dried without smoothing; however, it reflects the texture of the felt blankets used in the manufacture. The same effect is achieved in a slightly different way on mouldmade paper. Watercolour used on this surface 'breaks' attractively, often leaving white highlights on the peaks and pooling in the minute troughs in the paper. Note that one manufacturer's rough may be like another manufacturer's Not, so it is always worth experimenting.

Not is an abbreviation of 'Not Hot Pressed'; it may also be called cold pressed, particularly in the USA. Its manufacture involves being cold pressed without blankets to flatten the texture, and it has a finish half-way between rough and hot pressed. It is a useful watercolour surface with which to begin.

Hot pressed describes handmade and mouldmade paper with a smooth finish. It is not an ideal watercolour surface because all its nice receptive troughs have been ironed out so it cannot take many washes. It is good for a pencil or ink drawing highlighted with a single wash. I occasionally use it for coloured plans of gardens.

The watermark is the maker's mark which is impressed into the paper and becomes visible when held up to the light. It allows you to distinguish between papers, and identifies the 'right' side. But don't be hidebound, try the 'wrong' side – there is no reason not to.

Only handmade and mouldmade sheets of paper have deckle edges: wavy edges of uneven thickness. They can be an attractive addition to a painting, although on lighter weights of paper are often lost when these are stretched. Their character can be imitated by tearing the paper edges randomly. I occasionally collage torn paper onto my paintings to add interest and texture.

When working with watercolour you will need to fix the paper onto a drawing board. Although some artists use spring clips, I generally use masking tape from an art shop – this is not too sticky – if I am not stretching the paper. Fix stretched paper with gummed paper strip.

Specialist paper suppliers will sell by mail order, but usually only in quantity. When starting off, it is wiser to buy single sheets or pads from retailers and experience a variety of papers.

NOT PAPER

On Not paper, detail is more defined as the grain is less distinct. It is a good choice for more detailed botanical work.

HOT PRESSED PAPER

This paper gives a flat effect; only hair marks show when a dry brush is used, as there is no grain to reveal.

STRETCHING PAPER

You don't need to stretch paper if it is a heavy weight over 140lb (300gsm) or if you are not going to wet more than 50 per cent of the surface at one time. However, when I embark on a painting I don't always know how wet or dry the work is likely to be, so I generally stretch my paper anyway. And quite apart from the technical considerations, I find the process is an important part of the ritual of beginning to paint. As I prepare the paper – generally the night before – I am reinforcing the decision that I *will* paint tomorrow, and I'm often thinking of the specific painting I am planning. I suppose it's the painter's equivalent of the writer sharpening his pencils and beginning a new notebook.

Stretching can be done in a variety of ways. I distrust methods that sound laid back and talk about allowing the paper to relax. The method that gives me results is reminiscent of the action in a Buster Keaton movie – working at a cracking pace seems to be the only way!

MILLIE'S POPPIES
Watercolour, 5½x7¾in (14x20cm)
This little painting was made with a large No. 14 brush on unstretched Not paper.

First assemble the materials you need:

■ A DRAWING BOARD, not too lightweight, set upon a flat surface.
■ BROWN GUMMED TAPE available from art shops. Masking tape will not work. Tear four strips of tape, each a little longer than the sides of the paper (I also have extra strips ready in case I need reinforcement).
■ A CLEAN DAMP CLOTH for dampening the gum tape and removing excess water from the paper.
■ WATER Depending on paper size you will need access to a sink, bath or shower.

To stretch paper you must first wet it. You can do this by soaking it in a sink or bath for between 30 seconds and 1 minute, or wet it on both sides using a shower attachment. While the paper is being wetted, dampen the gum strip with the cloth. If you overwet the strip it will slide off the paper, but on the other hand if it is too dry it will not adhere.

Lift the paper out of the water and then allow the excess to drain off. The next stages need to be carried out quickly so that the paper does not dry. Take the damp paper to the board and smooth it into position with a

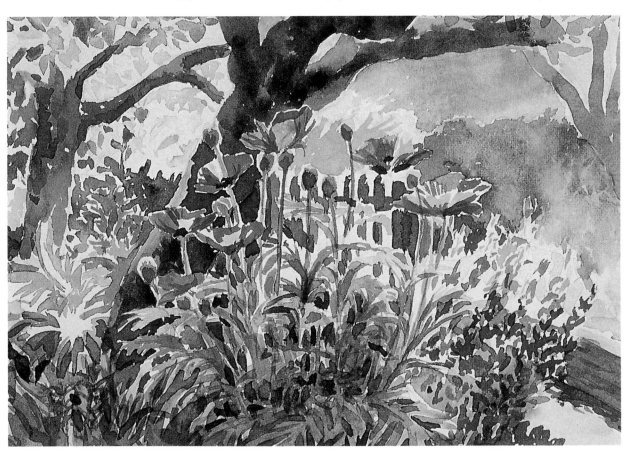

DAISIES AT
BARCHESTON
*Watercolour, 9x15in
(23x38cm)
Unusually, I used hot-
pressed paper for this paint-
ing, probably because I also
added coloured crayon to
some areas and HP
is a good surface for this.
At the first stage the flower
heads were masked out
with fluid.*

cloth, drying the edges slightly. Tape down one long side of the paper with gum strip, then a short side, and so on in turn. The paper will begin to cockle and move alarmingly: don't panic! If it begins to pull the gum strip off the board, fix it back with an extra piece of tape. Dry it on its board on a flat surface. For the most consistent results allow it to dry naturally, although a hairdryer can speed things up. All those cockles should disappear as the paper dries. Drying paper exerts a powerful force and if the board is too lightweight it will warp.

When you paint on stretched paper it will buckle again: don't worry, it will dry flat. Sometimes the paper will remain a little crinkled, especially at the edges. Use

your judgement as to how bad it is – a good framer can literally iron out minor bulges just by dry-mounting the finished painting. If it is too bad you can simply repeat the process. For the best chance of success I suggest using no lighter than a 140lb (300gsm) paper.

To remove paper stretched on a board, score the gummed tape with a knife along the outside edge of the painting and carefully lift the paper off the board. Some highly sized papers stick fast to the board, and when this happens, it is easy to rip the painting whilst trying to remove it. Again, don't panic. Use a flat ruler to ease underneath the paper and help it off the board. Once more, a good framer can make wonderful repairs!

PASTEL PAINTING MATERIALS

SOFT PASTELS

Pastels are made of ground, high-quality, lightfast pigments. By the addition of a binder of gum, or occasionally starch, they are mixed into a thick paste – called in Italian 'pastello'. Sometimes chalk and other coloured additives are mixed in to increase the covering power of the pastels. The paste is rolled into sticks and then dried to form the pastel. Here I am dealing with what are generally known as *soft pastels* – the dry, chalky sort – as opposed to *oil pastels*. Paradoxically, soft pastels come in a variety of hardnesses. The softer pastels have a higher proportion of pigment to binder.

I use a combination of pastels for my work. I love Unison handmade pastels because they are soft but not crumbly. They come in three sizes, none of which is too small, and I find that their scale encourages a broad, painterly approach. Unison have a marvellous colour range, including a dark blue that is a hard act to follow! Very dark colours that are not dirtied by the addition of black are not easily found in pastel. Pastel manufacturers have no standard way of identifying hues – some ranges have hundreds. Rowney's mechanically made, small-sized, very soft pastels come to my rescue when I am seeking a particular colour; their range of tints (colours with the addition of white) and shades (colours with the addition of black) is enormous. I also use harder Conté sticks for details and sharpening up edges.

When I began using 'soft' pastels I was demoralized by their messiness and tendency to snap and crumble at just the wrong time. But half my trouble was using the wrong pastel for the job. Hard pastels are most useful for preliminary outline sketches, and for defining details and highlights at the end of a drawing. For both gardens and flowers, greys, grey-greens and whites are often useful colours for these stages. Softer pastels are better for the more painterly passages where you need to fill in colour masses. My softer pastels are usually larger in size because the thicker they are the more 'structure' they

have, so that they are less likely to break. Their thickness also gives a broader, painterly stroke. And because I am using them for colour masses, these are the pastels I buy in interesting and sometimes brilliant hues.

The number of colours available gives you a clue to the limitations of this medium: colour mixing is not achievable in the same way as with paint, although limited mixing can be done in several ways (see pages 100–2). However, it is often necessary to choose just the right colour and tone of pastel for your work and so it is important that the colours are quickly – and visually – available for use. Pastel dust can transfer easily to other pastels via contact with each other or fingers, so that you end up owning a box full of grey sticks. For this reason it is best to keep them well separated. Some artists store them in grains of rice or sand – but the colours are not immediately evident and it's rather like a lucky dip. I have boxes with foam separators in which I keep similar hues together: they are labelled reds/pinks, greens, yellows, blues, greys/mauves, whites/tints and earths.

FIXATIVE

Pastel pigment adheres to paper mainly by gravity and by being trapped in the tiny holes (interstices) in the web-like structure of the paper. To bind pastel more securely to the paper (or other support) some artists use fixative. This is a binder dissolved in spirit and when it is sprayed onto a surface the spirit evaporates. Even with the use of fixative, pastel works need careful handling as abrasion can remove layers of pigment. Fixative may also darken the colours of some pastels, which is why some

GARDEN BY THE HELFORD
Pastel, 14½x11in (37x28cm)
Pastel is a good medium for conveying both highlights and the different textures of foliage. The foreground is busy with a rustic fence and tapestry of planting contrasts, with the estuary and land beyond. The house leads the eye to the distance.

artists avoid using it. I find that this has never really bothered me. If necessary, I touch up small areas of highlights after spraying – these remain unfixed and fragile but at least I know that the rest of the painting is protected. Darkening usually happens with pastels that have had black added to make them a darker tone. Unison very rarely add black to create this sort of effect; their dark colours are usually pure pigments mixed in various proportions, so they remain the same hue when they are fixed.

Fixative is also very useful for building up the 'tooth' or 'key' of the paper. If you have filled all the interstices of the paper with pastel, to a point that it will accept no more, spray on a layer or two of fixative. This should provide enough texture (tooth, key) to allow further pastel application.

When using fixative you should tape the work to a vertical surface; on a flat surface large drops of fixative can fall on the paper and create ugly blotches. Spray evenly without over-wetting the support. Begin at the top of the work and spray back and forth across the painting from a distance of about 12in (30cm).

DAMP CLOTH

Pastel can be a messy medium, and an important part of pastel work is keeping the colours as clean and clear as possible. Grey hands muddy the painting so a damp cloth is essential for hand cleaning – a carton of wet wipes is useful for working outdoors. In my case I find I control pastel on the paper but not necessarily on my person. Many's the time I have worked on until the very last moment, leapt in the car and arrived somewhere covered in pastel body decoration – much to the great amusement of passers-by!

DRAWING BOARD

Any stiff board can be used to support your paper, but for most work you will choose one with a smooth surface. A rough board will change the character of your work: a pastel technique called *frottage* involves rubbing the pastel over paper placed on a textured surface to create an image rather like a brass-rubbing. Remember this when using a board on which you have previously stretched watercolour paper: the gummed paper left on the board will produce strong lines in your pastel piece.

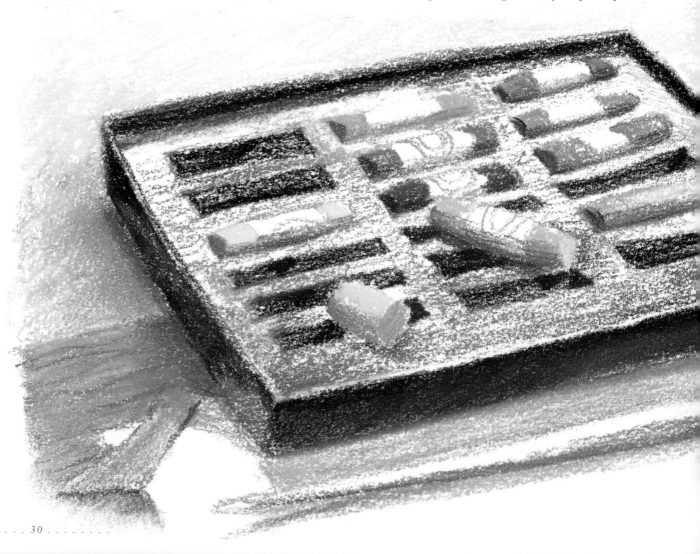

MASKING TAPE

This is used for taping the work to the board, or for masking off areas which are not to be painted. Masking tape found in art shops peels easily from paper without tearing it. However, beware of buying cheap tape which can be too sticky. Never leave it on the paper for too long or expose it to too much sunlight or heat, as it may be difficult or impossible to remove and may damage the paper. For preference you should use spring clips. These are easily moved so that you can work right up to the edge of your paper.

BRUSHES AND ERASERS

If I need to remove a large area of pastel I begin by using a stiff bristle paintbrush with a scrubbing action. I then use a plastic eraser to clean the area more thoroughly. If

I need to bring the paper back as close to its virgin state as possible I will then try a 'grittier' eraser, being careful not to abrade the paper. Pastel painting can be done on your own prepared boards so it might be useful to have a set of decorator's brushes and a large watercolour brush for this purpose.

BLENDING TOOLS

The traditional tool for blending pastel work is a *torchon* – a tightly rolled stump of paper. There are several sizes, and as the ends become dirty the paper can be peeled back to expose a new tip. Cotton buds are a good alternative, although they tend to lift pigment from the paper whereas the torchon presses it in. To me there is no real substitute for the perfect blending instrument – the finger.

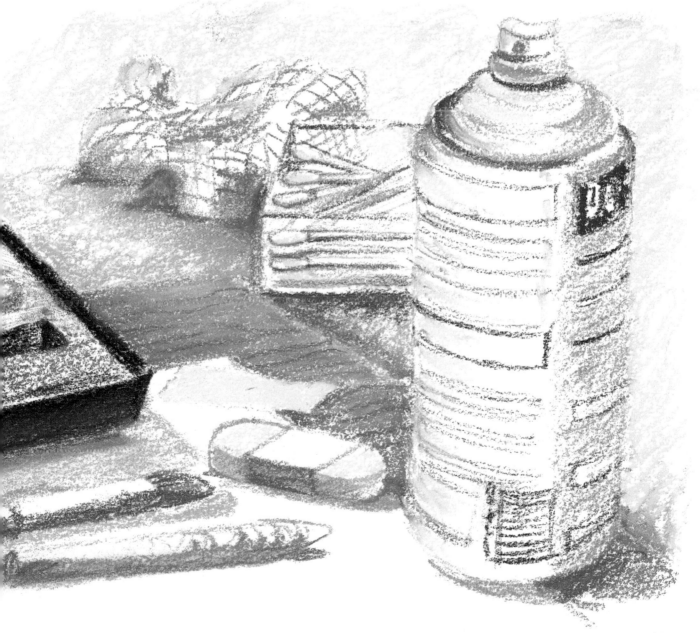

SUPPORTS

Paper and cardboards are the most widely used supports for pastel. Again, artists' quality supports are the best choice as they will not fade or yellow with age and they come in a variety of colours. However, you can certainly experiment on cheap 'sugar' paper – just be sure to choose something with an appropriate texture. As explained in the watercolour section, paper is made of a web of fibres with minute holes (interstices) in it – these are important for holding the pastel powder in place. The surface texture of the support is described as the *tooth* or *key*, and the rougher the surface texture the greater the tooth and the more pastel powder it will hold. The choice of texture will change the overall effect of your painting and you should choose an appropriate support for your style and subject.

Watercolour paper is fine for pastels but whereas white is the preferred option for watercolours, pastel supports come in a wide range of colours. You can of course underpaint watercolour paper to your own requirements. The colour of your support will interact positively with your painting and can change a subject radically. My favourite paper is French-manufactured Canson Mi-Teintes, a medium-weight paper with a strong waffle-like texture on one side and a smoother reverse. My favourite colour is 426 Gris Clair, a warm mid-toned grey; it is a lovely middle ground against which both light and dark tones show up well.

Apart from Canson there is Ingres paper, which has a ribbed texture not unlike 'laid' writing paper and is thinner and more delicate. Other supports are sand-coated papers and boards (you can even use fine sandpaper although I hate the feeling!) and brown wrapping paper (not the shiny kind). You can also make your own boards with a specially prepared surface by brushing on a thick mix of acrylic gesso, paint and pumice powder – all these products are available through good art shops.

Papers and pastel boards can be bought in art shops in sheets. There are also bound pads of paper which have a variety of colours and are good for beginners. I buy my Canson in large rolls 33ft (10m) long by 60in (1.50m) wide – always an interesting purchase as I am 56½in (1.45m) tall! This is a slightly cheaper way to buy paper and means you can work on a really large scale if you want. The only drawback is that it comes off the roll with a tendency to curl. To overcome this I sometimes spray it very lightly with water from a hand spray and then dry flat with a hair dryer.

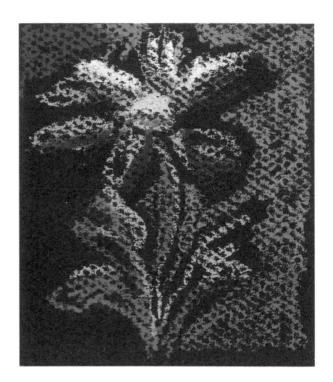

This flower was painted on the distinctive waffle-textured 'right' side of Canson 448 paper. The dark-toned support gives the pastel colours real vigour which, if not handled carefully, could become garish.

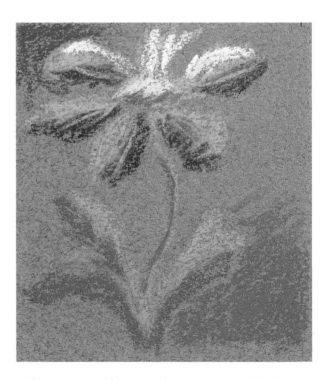

The support used here is my favourite Canson 426. I have painted on the flatter-textured 'wrong' side of the paper, which produces a more evenly shaded effect and encourages you to use the pastel in a different way.

One half of the flower is painted on a warm grey Ingres paper, the other on the reverse side of brown wrapping paper. Both have a distinctive linear grain – the lines of the Ingres paper are finer.

This paper is a blue-grey tinted Bockingford watercolour paper. You could tint white watercolour paper any colour you wish with your paints. This tint dulls the pastel colours slightly and the texture of the paper is evident.

The examples on these two pages have all been painted with the same range of Unison pastels: grey 28, red 18, yellow 6, green 30, blue/green 10, grey 21, red 9, blue/violet 10, green 25.

HEALTH AND SAFETY

Pastel dust is something to be wary of and inhalation should be avoided, even though most manufacturers have now eliminated the more poisonous pigments from their ranges. You may find that cadmium – a poison – is still used in yellows and reds but generally at a level below that permitted by law. As a sensible precaution it is best to work in a well ventilated room – this advice applies to the use of fixatives, too. Even with the low-odour fixatives available I often spray my work outside.

COMPOSITION

We spend our lives taking in visual information, sorting and organizing it to make sense of it. Composing a painting is just one step further on; it is the art of balancing elements in the picture space, giving a strong basic design upon which you can confidently build details.

CHOOSING A FORMAT

I am a great believer in the sketchbook (see page 42) and I think it is a valuable place to work out your compositional ideas. But remember, you don't have to be limited to the rectangle of the piece of paper that comes from your book or art shop! Your choice of *format* – the shape and size of your paper – can influence what you are painting. The subject matter will suggest a particular format. Traditionally, a long horizontal landscaped shape is considered suitable for peaceful landscape subjects. A circular format lends itself to a painting with an exciting 'bird's-eye' viewpoint, where elements are arranged concentrically. A square is symmetrical and balanced, so if you want to reflect these qualities in your painting a square format will give you a good start. A tall 'portrait' shape is traditionally used for portraits. Experiment with different formats. We are so used to seeing rectangular pictures that this shape is our first, obvious choice – but it need not be.

USING A VIEWFINDER

A viewfinder is a very useful piece of equipment for helping you choose a format. It is simply made of two L-shaped pieces of paper or card taped together to produce a variable frame. Make a rectangle and look at your subject through this. Turn the aperture round so that the vertical dimension is the longest and view your subject as a portrait format; then view your scene as a landscape format. Manipulate the frame to produce long, thin shapes or squares. You can even cut oval, circular or triangular viewfinders. The most important thing is to consider the choices rather than automatically choosing a standard piece of paper. Once you have decided on the

WALLED GARDEN, MOTTISFONT ABBEY
Pastel, 20x35½in (52x91cm)
These illustrations show different viewpoints of the same painting. For the entire painting I felt a landscape format suited the tranquil scene. The eye can wander around the picture, lighting on different focal points – not unlike the experience of walking in a garden. I used an old card window mount to mask off unpainted areas; this helped me to balance colours and masses within the area I was currently painting. It is also interesting to use a window mount as a kind of viewfinder. By placing it over existing paintings you may be able to produce several satisfactory compositions. The lower illustrations are in a portrait format – which is more suited to the strong focal point of the single tree or arbour in each case. Each 'extract' has a different balance of light and dark areas and verticals, horizontals and diagonals – but they all work as compositions.
Although this painting has recognizable features like trees and plants – it is really about the organization of abstract shapes, colours and textures. Rather than worrying about being strictly representational, I enjoyed using colour and exploiting the advantages of using pastel. As I worked I often stood back from the painting to judge the balance of masses, hues and tones, and modified areas accordingly. It may be difficult to see in reproduction, but the overlay of orange over ultramarine on the underside of the central 'lollipop' tree to convey reflected light in a shadow area was a later modification. If you need to change things, pastel is certainly a more forgiving medium than watercolour. To have conveyed the same thing in watercolour I would have needed to have planned the order of laying washes well in advance.
Focal points are not only created with shapes and colours – you can create interest for the eye by your textural handling of paint or pastel; see later sections for techniques such as scumbling with pastel or using watercolour wet on wet.

format it may be helpful to cut your painting paper to the correct proportions. If you can't bear to cut down the paper, draw a strong outline of the shape and try to keep within it.

VIEWPOINT

No doubt you will go on to create compositions without the aid of a viewfinder. Keep in mind that you are not

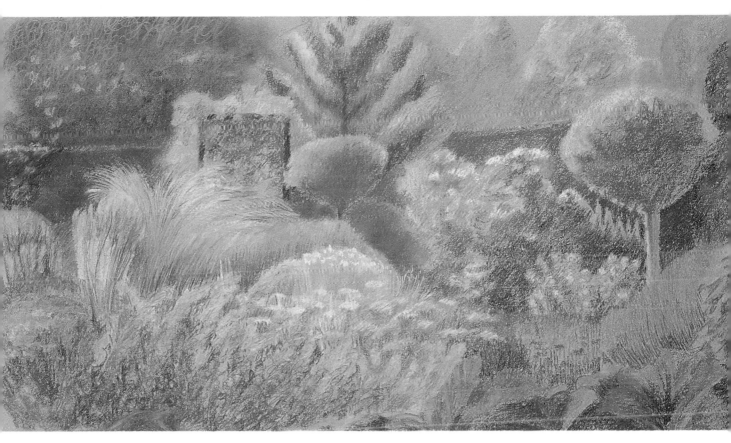

bound always to look at a scene in one way. Alter your viewpoint and you can re-structure the composition of your picture. Consider looking at a garden through a window or doorway; perhaps you could change your viewpoint significantly to cause a shift in the horizon line or increase the importance of the foreground. Changing your angle of view is an interesting exercise to apply to a still life of flowers. For example, looking at an

arrangement from a low viewpoint can make the blooms appear monumental, whilst looking down from a height can emphasize the importance of pattern (see step-by-step page 97).

THE BASICS OF COMPOSITION

A viewer's eyes scan a painting so as to see the entirety. (In the Western world we tend to scan left to right as we

would read.) Now and again the eyes rest on a particular spot, making that the *focal point*. A painting may have one major focal point which catches the eye, but there are generally secondary points which move the eye around the painting. The balance of all these points determines the *structure* of the painting. It is helpful to plan these focal points like a geometric design, so that the eye is led from one to another along a structured route. In your painting these points can be 'spotlighted' in many ways: by varying their colour, tone or texture for instance. When trying to *balance* individual elements in the picture space you must take into account their size (*mass*), lightness or darkness (*tone*), and the character and intensity of their *colour*. Try to 'feel' them in terms of weight and impact on the paper. For instance, a small dark area in the painting will balance a greater area of light space; a handful of vibrant poppies will be balanced by a large green field. You may find you are able to organize your colours more successfully if you do not choose a huge range to begin with. Exercises like the one on pages 72–3 using a limited palette can help you to look at the way you compose colour on the paper.

In general you are aiming for your eye to glide smoothly round the picture. Thus if you put all the light values in one area of the painting your eye may be drawn too strongly to them. Equally, if all the darks are lumped together, that part of the painting will be heavy and unbalanced. The same applies to colour; a startling hue will need its equal elsewhere in the painting or the sight will naturally remain fixed on it.

So it is important to plan the composition from the moment you first encounter the view that fills you with such enthusiasm. Again using our viewfinder, you can begin by mentally filling the frame, refining your choice of subject. It is a marvellous device for making you abandon the superfluous and home in on the really interesting parts of a composition. Then come the sketches that work out the basic balance of elements (see pages 42–5). Later, as you paint, you continue to think about the composition: now your focus is upon colour and tone and how to adjust them to achieve overall balance. With pastel you have a greater chance of altering colour and tone; it *is* possible to modify them in watercolour, but the medium demands more pre-planning.

USING MOUNTS

I have several old card window mounts which I find very useful for checking on composition as I am building the finished painting. It is often quite difficult to make decisions about how colours balance when you have large areas of unpainted watercolour or pastel paper. Masking off these unpainted areas with a window mount aids your judgement.

Using one of your own paintings or a reproduction, it is an interesting exercise to use a window mount (or four strips of paper) to create smaller compositions within the whole; see, for example, the painting of *The walled garden, Mottisfont Abbey* (page 35). Move the opening over the picture until you make a composition that 'feels' right, and then try to analyse why. Next, look at the balance of verticals and horizontals, and note if there is any obvious underlying geometric shape leading your eye round the picture. How do the colours and tones work alongside each other? Could you create an equally satisfying composition if you were to make the window horizontal instead of vertical?

Having urged you into mental gymnastics I don't want you to 'analyse and paralyse'. Repeat this exercise in the garden using your viewfinder and your sketchbook – and enjoy it.

WHAT SHALL I PAINT?

More to the point, how can one edit all the possible choices? It is time to try and work out what it is that interests you about a scene, and to hold that idea or feeling strongly in mind when painting. The following pages illustrate a few examples of what I have chosen and why.

Light makes the visual world possible: without light we couldn't perceive colour or readily understand form. When I walk into a garden or look at flowers, the subjects that really stand out for me are those which display strong characteristics of light or colour, or – which is more likely – both.

In *Tiered tulips*, a study of a garden in late spring, the afternoon sun was low and back-lit the tulips, giving them a lighter edge – almost an aura. The strong sun was filtered through the trees to the right of the painting: this light effect made the form of the trees of secondary importance. The building to the right was a partial barrier to the light, but its roof was also caught obliquely in the sun's rays. Contrasted against the strongly modelled forms of the foreground topiary hedge, the building appears almost 'smoky'. I visited this garden on one of its open days and had limited time to capture the scene, so this was entirely painted from the very strong tonal sketch on page 44. On another level the picture can be

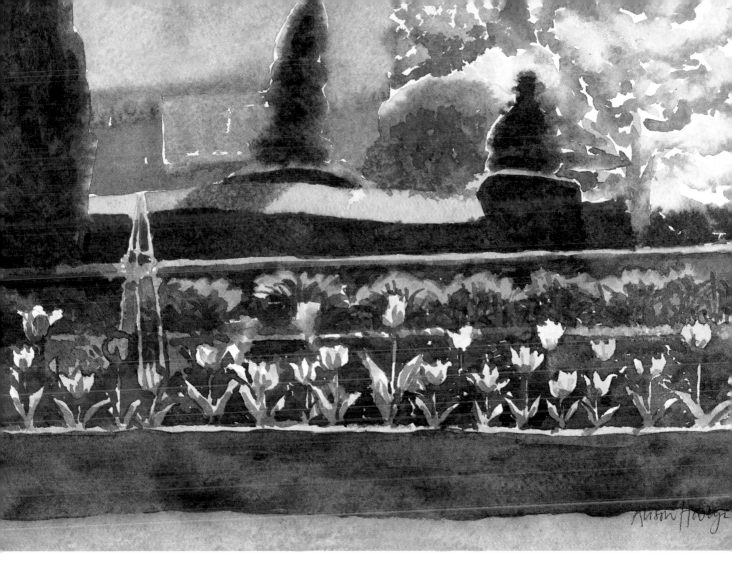

▲ TIERED TULIPS
Watercolour, 8½x11in (22x28cm)
This study of light uses a limited palette of colours in order
to focus on the tonal values.

▶ WINTER FLOWERPOT
Watercolour, 8½x5½in (22x13cm)

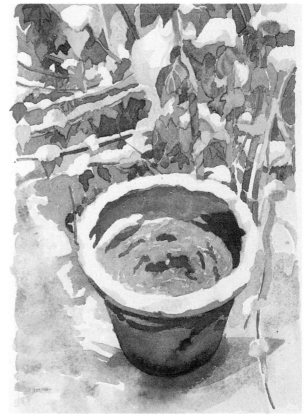

viewed as a jigsaw of shapes, tonally balanced against each other. The vertical topiary and cane frame are in strong contrast with the horizontals of the terrace and building. Moreover, the painted end result shows clearly that botanical and architectural detail was less important to me than was the desire to convey the essence of the scene and its very particular lighting.

The paintings *Winter flowerpot* and *Watering can* (see page 4), zoom right in on the subject matter. You don't have to have a grand garden at your disposal in order to produce a pleasing painting: looking closely at seemingly insignificant things can transform them into noble subjects. What particularly interested me here was the way that just a little bit of colour went a long way.

Snow is white; but is it to a painter? In the painting of the flowerpot I was able to use washes of cerulean, ultramarine and violet for the shadows on the snow, and these beautifully highlighted the burnt oranges of the pot. It seemed a brave little scene to me. The flowerpot glows in the middle of all the chill and the leaves cling tenaciously on to the lavatera even though weighed down with snow. The watering can lies waiting to be used once more and in the background the warm colour of the raspberry canes might hopefully herald a thaw. The close-up views and the bright winter sunshine sharpened the focus on the subjects and so I painted them in some detail and with a careful style.

This almost gastronomic collection in *Late summer flowers* provided a riot of colour. I responded to these flowers on two levels: I wanted to record their botanical forms, but I also wanted the painting to grow beyond that into an almost abstract area of colour. The way the composition is lit is of secondary importance here. The whole work is extremely busy and I wanted the intense colours of the flowers to be thrown into relief by the dark-toned lower half of the work, created by layering pastel over a watercolour wash.

In *Flag iris; Lumio, Corsica* (pages 40–1) we move from late spring in an English country garden to the same month in the plot of a house in Corsica. Here the word 'garden' has a different meaning, stretching out to meet the landscape and those awesome mountains beyond. Both colour and light attracted me to this subject. The soft blue-violet of the mountains was produced by the evening light and was a lovely backdrop for the warm yellow flag iris. Because they seemed to me to be of the same importance, I wanted to give the massive, enduring mountains and the delicate, ephemeral flowers equal billing! Obviously, I could do this with the help of perspective and close attention to detail in the portrayal of the flowers. The blooms and the tree trunk vertically balance the horizontals of the mountains and table top.

Gardens and flowers provide endless choices of subject. And don't be afraid to tackle something that looks 'difficult'; you *will* find the techniques to get you there! Equally, don't ignore something that seems humble; when you paint you can view everything with new eyes.

LATE SUMMER FLOWERS
Watercolour and pastel, 23½x23½in (60x60cm)
The frame and borders are purposely wavy to enhance the feeling of movement and growth in the painting.

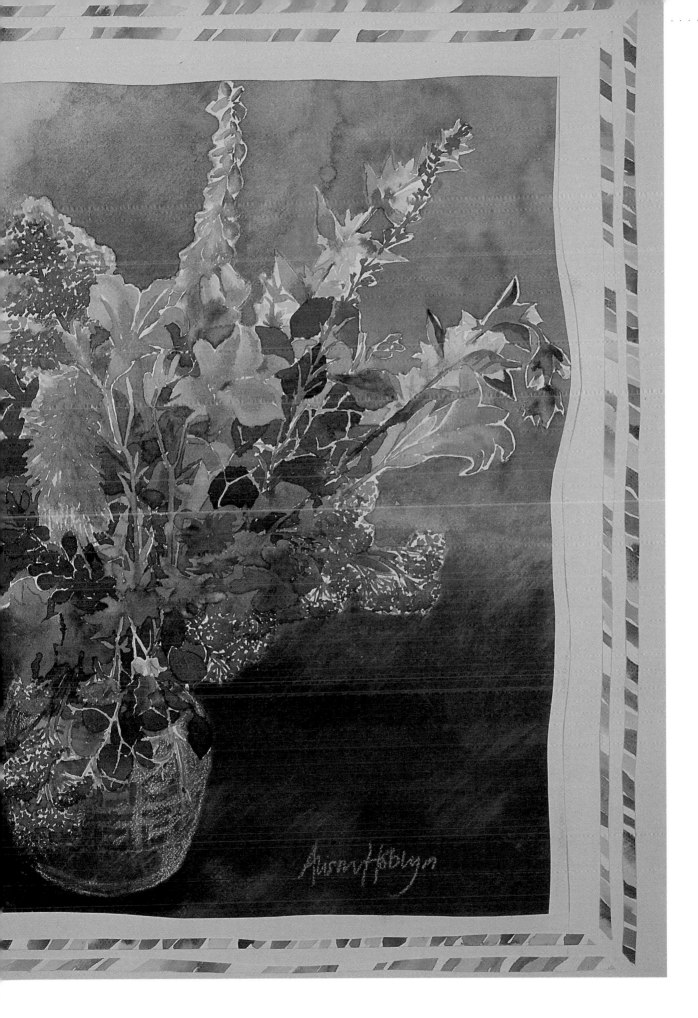

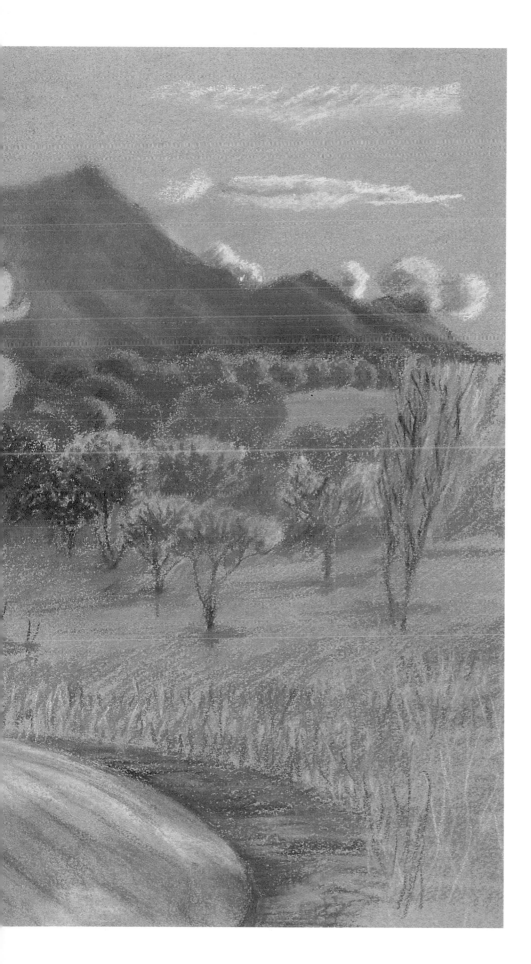

FLAG IRIS;
LUMIO, CORSICA
Pastel, 14½x20in
(37x51cm)
The violet-blue mountains
seen in this painting are a
near complementary colour
to the orange-yellow iris.

USING A SKETCHBOOK

A 'sketch' is a useful shorthand name for a drawing that conveys an idea, although I have a slight resistance to the word because it also implies a drawing that is hastily rendered without much thought. Quite the opposite is true for most artists – the sketchbook is where thinking begins. The first drawings are a valuable underpinning for further work and may also reveal that an idea will not work. So my sketchbook is part maternity ward and part graveyard! It is certainly the one piece of equipment that goes everywhere with me, along with a selection of pencils, a sharpener and eraser. I use chunky A5 sketchpads of bound Not watercolour paper. This may be extravagant for black-and-white sketches but the slight texture is interesting for pencil work and allows me to use my paints for colour notes. I have also been known to become so engrossed that I produce finished paintings in my book.

Our time to paint always seems to be limited by other pressures. When painting outdoors it is restricted by the weather: light changes so swiftly even on the most even-tempered day. So it is hard to take some of that valuable time to prepare. Before beginning the final painting of any subject I always pull out my sketchbook and do some very fast compositional sketches. They need only take five or ten minutes and they are very valuable for confidence building. If you have made a considered decision about how and why you like the subject matter you begin your work on a much stronger base. So much of painting is about confidence. I often embark upon work with the equivalent of stage-fright. Thus, although students may moan at me for preventing them wading into their final painting, they generally see the benefits. I understand their belief that they can only paint when inspired, and that spending too much time on analysis and re-drawing the subject can dull their interest. However, I am only asking for ten minutes.

More important than anything else, the sketchbook is a safe place to develop your drawing skills and make lots of mistakes. I do believe that drawing with accuracy is a fundamental skill, and if your foundation is wrong all the clever painting techniques in the world will not mask it. For drawing and perspective techniques, see Chapter 5.

I use my sketchbook in four different ways: to make *compositional drawings* (this includes composing objects in the picture space and making decisions about tonal values); to make *colour notes*; to make a drawing from which I might *size up a finished work*; and last, to do small *finished paintings*.

COMPOSITIONAL DRAWINGS

When I sat down to do a painting of a corner of a garden overhung with laburnum I was mostly attracted by the colours and shapes. There were cushions of sage and globe-shaped alliums, and these curves were echoed in the lawn edge and the wrought-iron gates. The laburnum petals dotting the grass added to a highly patterned effect. I immediately saw this as a formal painting where everything is kept neatly within a square format, which to me suggests symmetry and order. The light was quite soft – sunlight filtered through clouds – which did not give strong areas of contrast. The exception was a shady area behind the dangling laburnum flowers, which threw them into dazzling relief. With such a strong pattern in my mind, my sketch turned out to be made up of simple shapes bounded by line, with just a quick application of tone. As I drew it, I realized I needed to increase the lawn area to balance the border. Generally my first approach was satisfactory (see pages 86–7).

Sometimes my initial thoughts on the composition of a painting are not so clear, and then I may spend more time working it out in thumbnail sketches. For example, when deciding on the composition for this border my eye lit upon the dovecote and it featured strongly in my

▶ *Study,*
THE LABURNUM
LAWN
Pencil, 6x5½in (15x14cm)

portrait format sketch, balanced against a vertical juniper. I went on to draw a landscape format sketch and began to get more involved with looking at the planting, its textures and positioning, and the way it was lit against the shaded wall. Eventually I decided the dovecote needed to be less centred and the large tree should be balanced by the wall of the house. A horizontal format is often used by artists for conveying peaceful ideas, and this helped me to portray a calm early morning.

In a quick final sketch I blocked in the tone and only then drew on my prepared paper. All three drawings were made with a soft graphite stick and an HB pencil. Each time I drew the subject I learned new things. The first sketch took about three minutes, the second fifteen minutes, and the third five minutes.

 Study,
DOVECOTE BORDER
Pencil, 5x8½in (13x22cm)

▶ Study,
DOVECOTE BORDER
Pencil, 5x4½in (13x12cm)

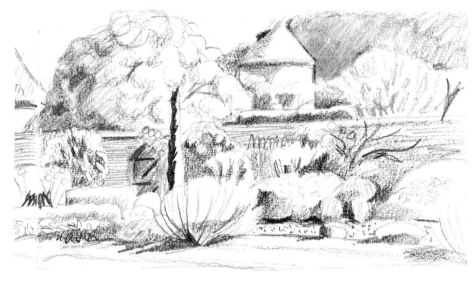

The illustrations on these pages show some of my working sketches. On this page are the preparatory ideas for The dovecote border *(pages 12–13). The viewpoint varies slightly in each sketch, moving from a strong emphasis upon architectural features to more interest in the textures of the planting and the play of light – by taking some time over the middle sketch it became clear that it was this latter aspect which was interesting me. The bottom sketch is of the view I finally chose; in particular the shady end wall of the house helps to emphasize the light in the rest of the painting. In contrast, the sketch for* The laburnum lawn *(opposite) came together immediately and the view changed very little in the final painting.*

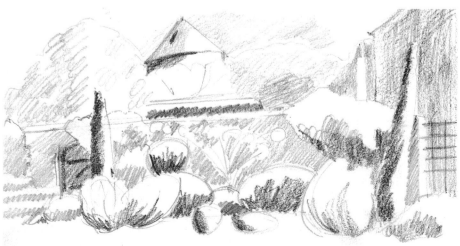

◀ Study,
DOVECOTE BORDER
Pencil, 4½x8in (12x21cm)

What interested me most about the gardens in *Tiered tulips, study* and *Barnsley House, study* was the interplay of light and dark. The terraced garden is low key tonally, most of the tones being drawn from the darker end of the scale with a few highlights to emphasize the depth of shadow. By contrast, in my sketch of Rosemary Verey's garden at Barnsley House, the darks counterpoint the much lighter areas. From my notes I see I was interested in the rich variety of greens and the different textures. I could now invent every green and I would have enough tonal information from the sketch below to produce a credible, tonally balanced painting.

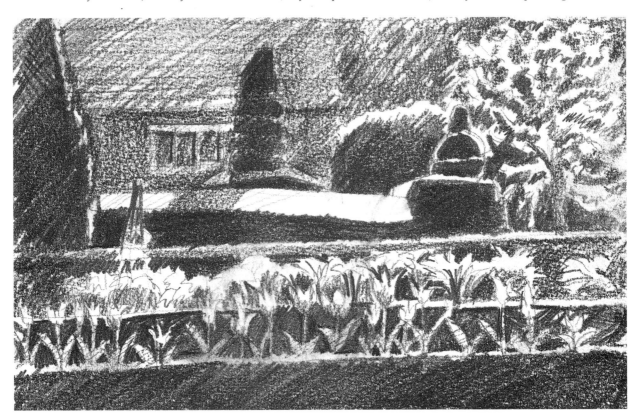

▲ Study,
TIERED TULIPS
Pencil, 5½x8in (14x21cm)

▶ Study,
BARNSLEY HOUSE
Pencil, 6¼x6in (16x15cm)

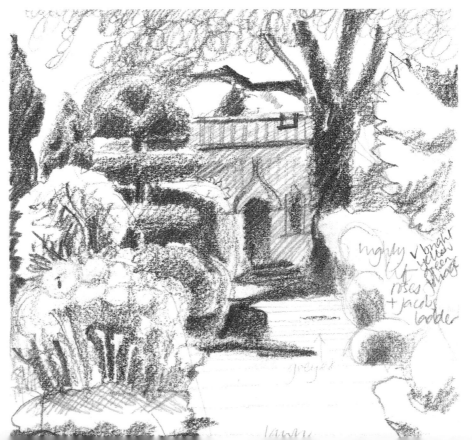

From the pencil sketch of Dunbeath I worked out that I wanted to compose the final picture split roughly 50/50 along the horizontal. I spent most of my time on site painting the garden in detail, and so the sea was painted later entirely from the sketch and colour notes. (See pages 84–5 for finished painting.)

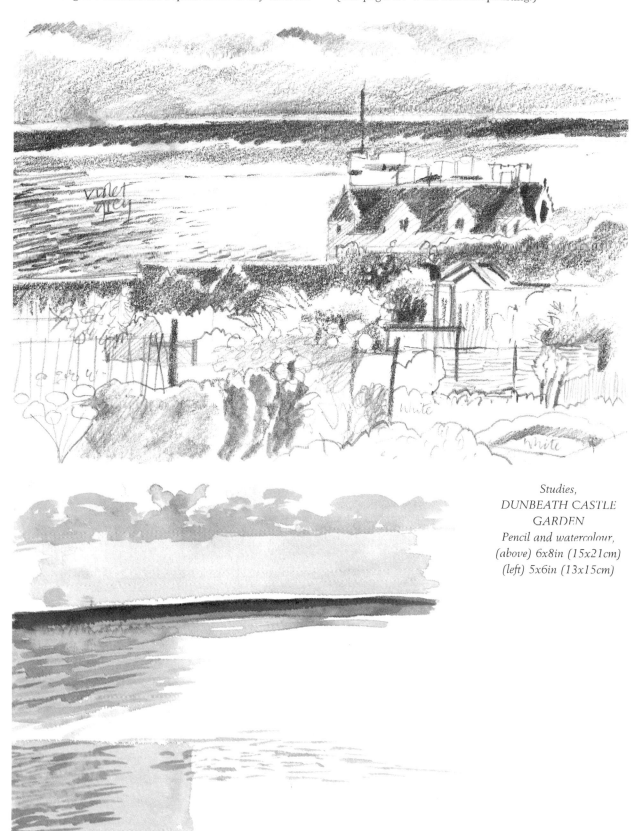

Studies,
DUNBEATH CASTLE
GARDEN
Pencil and watercolour,
(above) 6x8in (15x21cm)
(left) 5x6in (13x15cm)

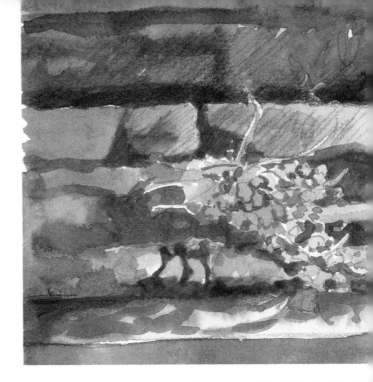

COLOUR NOTES

I often pick up my sketchbook to make detailed colour records of small areas. The information seems to seep into the subconscious and can be recalled when tackling a similar subject. Although it is probably not easy to see in reproduction, the terracotta pot in the study of toad-flax is underpainted with a pink that I would definitely use again. I also enjoyed using ochre, cerulean, violet, Payne's gray and dark green mixes on the wall. It wasn't just one stone-brown colour – and now I shall have that in my book for reference.

The sketch of an apple bower and alliums reveals a painting that is light and without great contrast in tones. In fact the interest here lies in the pattern and the colour. In a full-size painting I think I would probably develop the hues of the alliums in order to provide a balance against the greens.

The sketch shown opposite of a kitchen door is quite different, and displays a strong tonal contrast between the inside and outside. Nevertheless, the dark interior does not have to be painted murkily; there is plenty of scope here for many, coloured, wet-on-wet washes. I would probably stick to the same limited range of colours: one group links all the interior space while the lime greens suggest the garden outside. My inclination is to gravitate towards watercolour for quick colour notes because a small tin is so portable and more colours can be made from less raw material.

SIZING UP

The little sketch of the wild garden at the Castle of Mey, the Queen Mother's home in Scotland, illustrates a way of sizing up your sketches to a bigger scale for the final painting. On tracing paper, draw a squared grid that fits the dimensions of your sketch, and place it over the drawing. Now very lightly draw a scaled-up pencil grid on your final paper; for instance, the sides of the squares might now measure twice the length of the originals. You may need to do some simple mathematics to make sure it all fits on your paper. The next step is to study the contents of each small square, and then to copy the major lines into your big squares. And there you are. A perfectly fitting, perfectly accurate (as long as the initial sketch was) drawing.

Study,
APPLE ARBOUR
Watercolour, 8x6in (21x15cm)

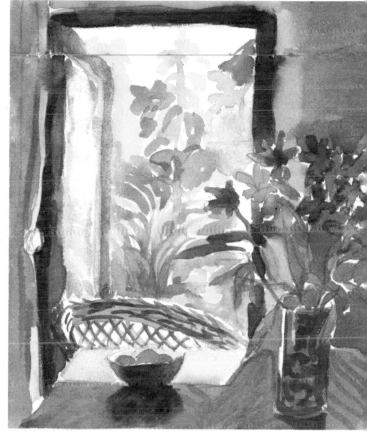

▼ *Study,*
KITCHEN DOOR
Watercolour, 7x6in (18x15cm)

▲ *Study,*
TOADFLAX
Watercolour, 1½x8in
(12x21cm)

▼ *Study,*
CASTLE OF MEY
Watercolour, 6x8in
(15x21cm)

▲ GOLDEN FARM
Watercolour, 7x8in
(18x21cm)
The brick-red façade was a
perfect complementary to
the greens of the planting.

▶ PANSIES
Watercolour, 8x6in
(21x15cm)
The soft colour of these
flowers translated well to
watercolour.

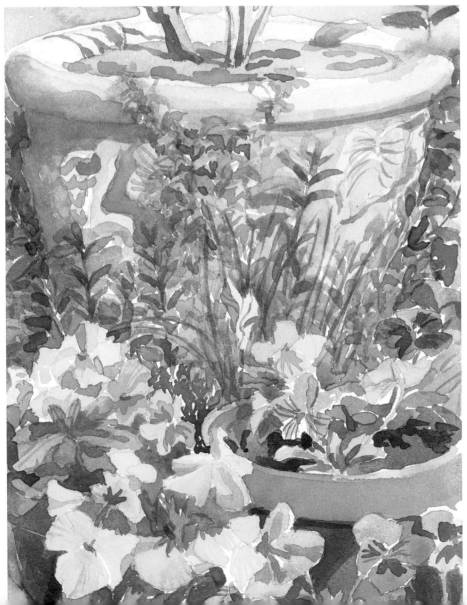

FINISHED PAINTINGS

Sometimes the format of the sketchbook is just perfect for a finished painting. I really enjoyed sitting on a rock painting the watercolour of Golden Farm in Menorca – who says small isn't beautiful and that you can't capture detail on this scale! Equally, I enjoyed painting the little vignette of pansies grouped in front of a stone pot. I can hardly believe it looked like that when I see it in the depths of winter.

USING PHOTOGRAPHS

Photographs can be helpful in several ways: to remind you of details; to help you see tonal values; and to work out your composition. However, I would never advocate copying from a photo. Painting from a photograph can be a trap. When taking a picture we make a 'snap' decision and compose the view in the unvarying rectangle of the print. This can be in portrait or landscape format, but essentially the proportions always remain the same. By seeing the view through a camera we have removed at least one element of choice and taken ourselves one step away from the subject.

If I use a camera, it is an adjunct to my sketchbook. It is valuable on those days when the light conditions are fleeting and you want to remind yourself of evanescent shadows. I take several overlapping photographs of my scene in order to end up with larger details. Because my viewpoint alters marginally with each shot, when the prints are taped together to form a montage the perspective does not work perfectly. This does not matter as I also make an accurate drawing on the spot. Taking several photographs like this also frees me from the restricting rectangle of the standard print. It may be hard to become so profligate with one's film – but you just have to see it as an investment.

I like to work as much as I can in front of the subject, often returning at the same time over several days in order to reproduce the same light conditions, as far as possible. On average I will have half-finished a painting before I look at the photos. If lack of time or weather conditions prevent me from working *in situ* I now have my photographs to enable me to finish the painting. By then the image is already well fixed in my head and they act as a safety-net.

Sometimes I am unable to do much work on location and return to the studio with compositional sketches and colour notes, possibly an accurate full-size drawing and a great many memory-jogging photographs. And if I haven't had time to work out the composition I may try and do this by 'cropping' the montage of photos with strips of masking tape or paper. These can be moved endlessly to create all sorts of different arrangements of the elements in the photo.

Although I think photographs are of dubious value in recording hue – I believe a painter needs to have a direct experience of colour – they can sometimes be helpful in enabling us to see tonal values more clearly. This is probably because photographic emulsion records a narrower range of tones than we see and thereby simplifies things. However, photos can mislead – for instance a photograph of a sunny day may be very 'contrasty' – the bright areas will be bleached and the shadows uniformly dark. When you paint this scene you will probably want to reduce this gap between tones and convey the sunny mood by a more interesting use of colour.

Finally, beware of spending too much time lovingly copying detail from the photograph, because your finished result may end up looking somewhat overworked and tired; above all you want to convey the freshness and spontaneity of the moment.

chapter five

DRAWING AND PERSPECTIVE

To artists, perspective is a way of representing three-dimensional objects on a two-dimensional surface to give an effect of solidity and distance. As a child I would try to make sense of books, which sounded like magician's instruction manuals, on this arcane art. Vanishing points, horizon lines and picture planes all flew theoretically in front of my eyes. But the theory used for constructing perspectives can only ever be a very useful guide. In fact, in my time as a designer I produced complicated architectural drawings, worked out by the rules, to find they often needed that final adjustment by eye to make them look authentic. Whatever your knowledge of the subject, the method I favour for our purposes is commonly known as 'sighting'. This comes down to looking hard and drawing what you see instead of what you think you see. Let's get things in perspective: in fact the word itself comes from the Latin *perspectiva*, 'to see clearly'.

SEEING AND DRAWING

When we draw an object we have to be acutely aware how much it changes in appearance as we alter our viewpoint. Having learned at an early age how to collect the various images of an object under one name, we have lost some of our capacity to see different views of the same object as unique. The neurologist Oliver Sacks (in the chapter 'To See and Not See' from *An Anthropologist on Mars*, Oliver Sacks, Picador) describes how a man who gained sight after 45 years of blindness had to learn how to see 'whole' objects; for him it was an enormous task to understand how an object could remain the same thing and yet appear so different when viewed from different angles. He even felt he must be seeing many individual things. As sighted people we learned to correlate all these separate images when we were young, and slowly began to see an object not in its many parts but rather as a synthesized whole. Eventually, we pigeon-hole this diverse visual information into a name; we see

'tree' or 'flower'. As artists we have to unlearn this way of seeing, and learn to see as that newly sighted man; each object is possessed of thousands of utterly unique views, but as artists we select only one to draw.

Delighted by this rich variety of choices, Paul Cézanne (1839–1906) declared enthusiastically:

The same subject seen from a different angle gives a subject for study of the highest interest and so varied that I think I could be occupied for months without changing my place, simply bending more to the left or right.

Because this technique of seeing in a discrete fashion (and it is just a technique to be developed like any other) has become so natural to me I sometimes wonder how others can *not* see like this. It gives me a great thrill to watch a new student stop drawing something as if copying the image in his/her mind and begin to draw it as it *actually looks* from his/her particular viewpoint.

Cézanne was able to appreciate how new everything could look when viewed from a different angle. As mentioned in the section on composition, changing your viewpoint can radically alter the sense of your picture – so look hard before committing yourself to painting.

SIGHTING

The simple technique of sighting helps us to see clearly. All you need is a good straight pencil and an ability to hold it vertically, horizontally and at an angle! The card viewfinder mentioned in the section on composition comes in handy for checking angles, as viewing your scene through this makes it easy to compare any objects to the vertical and horizontal sides of the frame.

It is worth spending time improving the accuracy of your drawing as it is the foundation of your painting. A common fault is to enlarge distant objects because as we focus on something in order to draw it in detail, it

becomes larger in our mind. Somehow we need to devise a way of relating the size of background and foreground objects. The easiest way is to measure them in 'pencil units'.

Look at your scene, maybe through your viewfinder, and then make some mental markers on the view. These might be a horizon line, the roof of a building, foreground pots and so on. Draw horizontal or vertical lines to locate these features roughly on the paper. You can then check that they have the correct relationship by *sighting*: hold your pencil out in front of you at a chosen distance, and when you have fixed this distance, don't change it or your measuring system will fall apart. Measure with your pencil the intervals between your chosen location features. From the horizon to the top of the pot may be two pencil lengths, and the pot itself may be three pencil lengths. You will probably not be able to transfer the literal pencil lengths onto the paper, but you can ask yourself, 'in my drawing does the pot occupy a

space one third longer in its vertical dimension than the space between it and the horizon?' Begin with one object in your view and make it your unit of measurement. So for example, that poppy head may fit eight times vertically into the length of the jug, or the bench may be a quarter of the horizontal dimension of the lawn. Of course, you are not going to get total mathematical accuracy measuring with a pencil, but what you are aiming for is a credible framework that will be modified by your developing instinctual skills. Believe me, the more you draw, the more these skills will develop.

SIGHTING
Hold your pencil at a constant distance from your body and measure along it by marking a point with your thumbnail. Shutting one eye helps you to focus. Here, the same measurement applies vertically to the dovecote and foreground flowers, and horizontally to the mid-point on the tree. Without checking by sighting it would be easy to record these dimensional relationships wrongly.

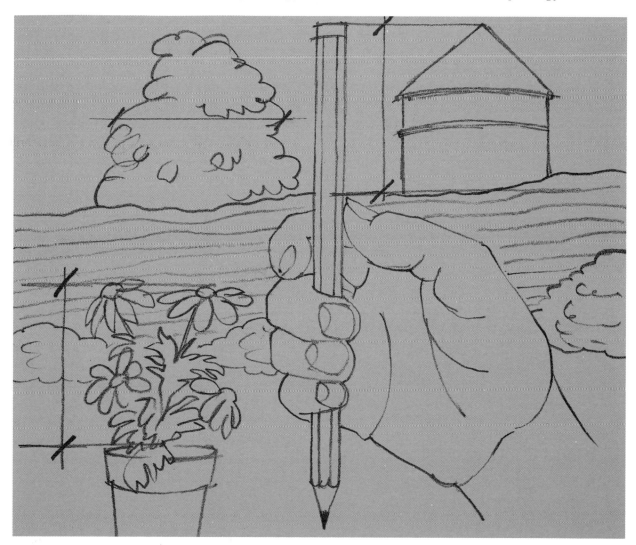

DRAWING FOR WATERCOLOUR
PAINTING

There is more than one type of drawing. The one in your sketchbook is generally a preliminary working-out of ideas. Then there are very finished drawings in line or tone that stand by themselves on the quality of their draughtsmanship. The drawing you make as a preparation for a painting has different characteristics to either of these. It needs to be quite considered so as to give accurate guidelines, but it need not be too detailed. The lines of the drawing are the bones and the paint will be the enlivening flesh.

To produce a guideline drawing I would use an H, F or HB pencil and apply the lines lightly: they will eventually be almost obliterated by the paint. For this level of drawing I do not get too involved with detail because I am simply locating everything on the page with the pencil line and indicating roughly the forms of things. The creative invention comes later at the painting stage!

Having worked out the composition in your sketchbook you will have a good idea of where everything should be placed on the page. If you are not using the sizing-up method described on page 46 it can be quite difficult to reproduce your sketchbook view accurately on a larger sheet of paper. You might find that the first thing you draw is too large so that you lose part of the view off the edge of the paper. It is important not to draw things too fully to start with because it is so disheartening to have to erase beautifully drawn detail! So, using the sighting method, locate the main elements and simply indicate that tree as a circle on a stick, or those

▶ *MY MOTHER'S*
FLOWERS
Watercolour and pencil,
16¾x14in (43x36cm)
This quiet rendering of
daffodils reflected my
mood; it contrasts with the
lively approach on page 17.

This illustration shows the
level of drawing I use for
watercolour, here using an
HB pencil. For light-
coloured areas I would use
an H pencil.

steps as simple horizontal lines. Then you can see that they all fit on the page.

I find it useful to home in on the most interesting bit of the painting and locate that on the paper first. Then, if you do not quite succeed in placing everything on the paper, at least you have the important bit. It is in my nature to leave the best until last but if this is applied to

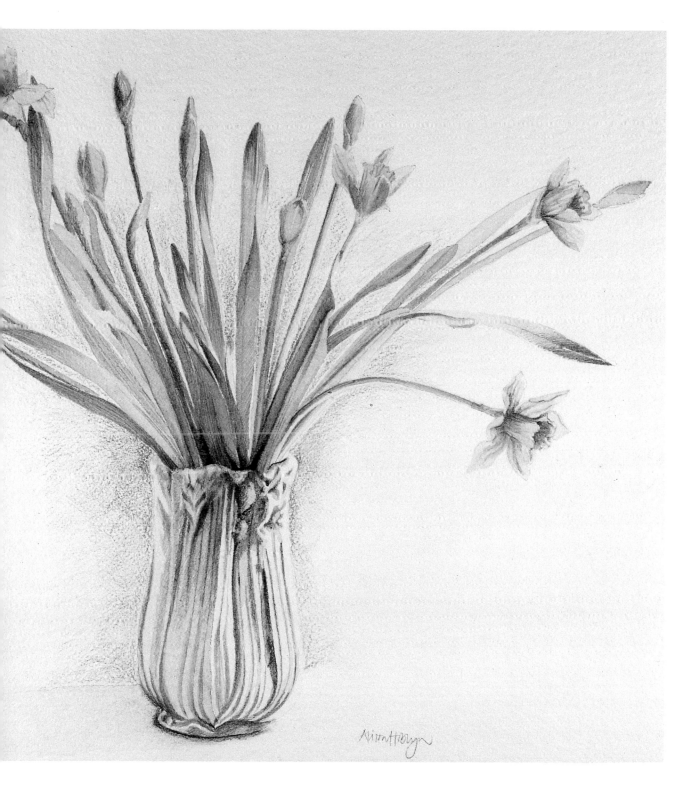

a composition and the 'boring' bits are doggedly drawn in first, there may not be enough room on the page for the 'best' part. Getting everything to fit on the page may seem very difficult at first, but your ability to do this will develop with practice.

You may have a stretched sheet of watercolour paper on your board but it is most likely that the proportions of this are not the same as your sketch. Before you begin to draw your final composition it is a good idea to draw a pencil-line 'frame' well within the paper's boundary. This helps in two ways: first, it reasserts the shape you had decided upon in your original compositional sketch (it is a temptation to fill up all the available space); and second, if you find you have misjudged the size of things,

THE BACK DOOR
Pencil and watercolour,
6x8in (15x21cm)

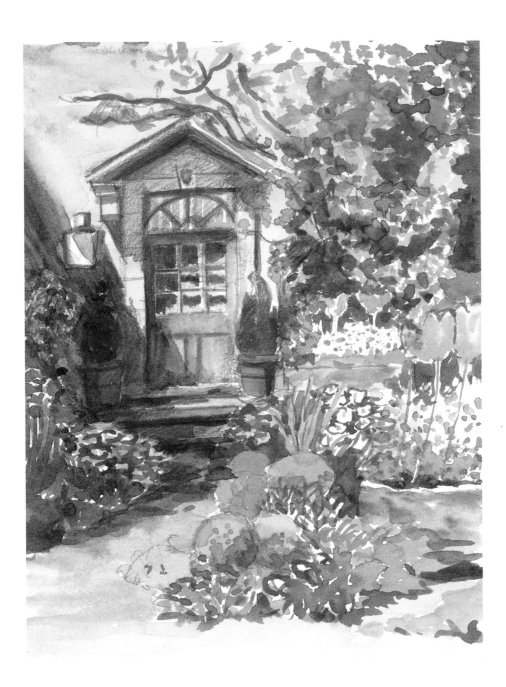

that border of white paper gives you some degree of room for manoeuvre.

Although my pencil lines are normally a guide for the paint, I sometimes want them to play a larger part in the actual painting, as was the case in *My mother's flowers (pages 52–3)*. These daffodils were some of the very first to emerge from a hothouse in midwinter. They were pale and delicate and therefore suited a quiet rendition. Because I wanted to use my watercolour washes very softly, with the merest hint of colour, I decided to use the pencil drawing underneath to show the small range of tones. I used the relatively hard pencils I mentioned before: H, F and HB. The finished painting is reminiscent of the way in which watercolour was widely used before the eighteenth century – as a means of adding discreet colour to drawing.

In contrast, the drawing for *The back door* was done quickly using a 2B pencil and a 6B graphite stick to show the greater range of tones in sunlight and shadow. The subject needed colour but I was pleased by the way the pencil strengthened the washes and added texture. Strong gestural pencil marks shining through a water-colour wash can provide a truly dynamic skeleton for a painting. I would counsel caution, however, for to make this style really work your skills of draughtsmanship need to be well developed.

DRAWING FOR PASTEL PAINTING

With pastel the line between drawing and painting is less defined. You need to put down lines in order to locate your subject before launching into the more detailed 'painting', and these need only be guiding outlines. Look at the way the blooms in the illustration *Hyacinths* are simple rounded shapes. Instead of using a pencil I chose to draw immediately with pastel and thus launch into colour right away. Grey graphite lines show up well on white watercolour paper, but the colour of pastel you choose for drawing outlines depends to a large degree on the colour and tone of your support. Let's assume it to be of a mid-tone value. To locate all the parts of your composition roughly on the paper it is probably useful to use a very light-toned or white pastel. Don't be too heavy-handed however; if you put down a white line too strongly in an area of the picture that is going to be dark, it will 'grin' through and be quite difficult to cover.

Having a choice of colours for drawing is a real bonus. Using pencil to map out a complicated floral arrangement is rather taxing because where the blooms intersect it may become difficult to see which line relates to which flower. With pastels you can just choose slightly different tones or colours to make the differences more obvious. For my first outlines I like to use a hue as near to the colour of the object as possible. I probably won't light upon the right choice of pastel immediately, but this first pick demonstrates to me how near I am in tone or colour. Thus from the very beginning I am looking at the view in terms not only of line but also of colour.

I also try to find a *tone* of pastel that mirrors the light conditions in the subject before me. For instance, when I mapped out the hyacinths the leaves were quite difficult to draw accurately as they intersected in a complex fashion. I used white to show where the light was striking strongly, and gradually darker tones of yellow and green for areas of diminishing light; this really helped me to recognize exactly 'where I was' when I started to paint in the details of colour and tone. And having picked quite blue/violet shades for the shadow areas, I soon realized that I wanted to make the painting much warmer in feeling. So when I went on to the next stage (see step-by-step in pastel, pages 113–15) my choice of hues was around browns, yellows and warm greens.

Outline drawing for
HYACINTHS
Pastel
See page 115 for finished
painting.

chapter six

UNDERSTANDING COLOUR

Colour is a major vehicle of expression for painters. This is no surprise since it plays a large part in our lives and can enliven or subdue our emotions. Theatres traditionally have 'green rooms' where keyed-up actors can rest. We 'feel blue' or 'in the pink' or even 'green with envy'. Red stands for danger while white symbolizes purity. The German philosopher Goethe researched into colour. He believed that it occupies an important place in 'the series of elementary phenomena', and that its effects are 'immediately associated with the emotions of the mind'. Its study isn't a finite science because there is a large subjective element. A colour may have different associations for different people or they may even 'see' it in different ways. How often have you disagreed with a friend about a blue shoe that is definitely black or puzzled over a piece of fabric that to her is green and to you looks blue?

SOME DEFINITIONS

A colour has different characteristics and artists use certain terms to describe those characteristics. *Hue* is just another word for colour, whether an object or pigment is orange or blue, red or green. A *saturated* colour is a colour or hue in its purest and most intense state. When colour is painted transparently or mixed with white to create a *tint*, or mixed with a dark hue to produce a *shade*, it is unsaturated. *Temperature* describes how 'warm' or 'cool' a colour is. Warm colours are those at the red end of the spectrum and cool colours are those at the blue end. We have all had the physical experience of a hot red flame or cold blue hands, but the way you use warm or cool colours in a painting can drastically alter its mood.

The terms *tone* or *value* describe the lightness or darkness of a colour (how much light a colour reflects or absorbs). One colour may be intrinsically darker than another (in the same lighting conditions dark red reflects less light than yellow) but its tone or value may also be changed by the effect of light upon it. Imagine two tulips: one may be 'dark' red, but if it is in full sunlight its tone may be lighter than the 'pale' yellow bloom in the shadow beside it. Trying to see value divorced from colour is one of the hardest areas to master, but it is a crucial skill.

Key describes the range of tones or colours within a painting. Thus a painting with *high-key* colour uses bright, saturated hues whilst *low-key* colour is more muted and greyed. Similarly, a painting with a tonal high-key draws values from the lighter end of the tone scale, while tonal low-key depends on using the darker tones. How you 'tune' the key of your painting can change its mood considerably.

ATMOSPHERIC AND LOCAL COLOUR

Placing one colour against another immediately changes its character: it may hide in its shade or become a total show-off. Lighting affects our perception of tone but it may also subtly alter hue, too (imagine, for example, golden evening light infusing green grass with a tinge of yellow). When a colour is changed in these ways by reflected colour from surroundings, or light conditions, it is described as *atmospheric colour*. Its 'true' hue when viewed in close-up is called *local colour*. However, I agree with the painter Josef Albers (1888–1976) that colour is seldom seen as it *really* is and 'deceives continually'. Henri Matisse (1869–1954) spent a lifetime exploring the interplay of colour and light. But before you despair in the face of these puzzling subtleties, let me assure you that there are practical issues in the creation of colour and enough guidelines to help you master the fundamentals of its application in paint or pastel.

A FEW RULES

For painters, colour is a powerful vocabulary and it is useful to learn some 'grammatical' rules, if only in order to break them. Theory is not easy to digest, but an

PRIMARY AND SECONDARY COLOUR WHEEL

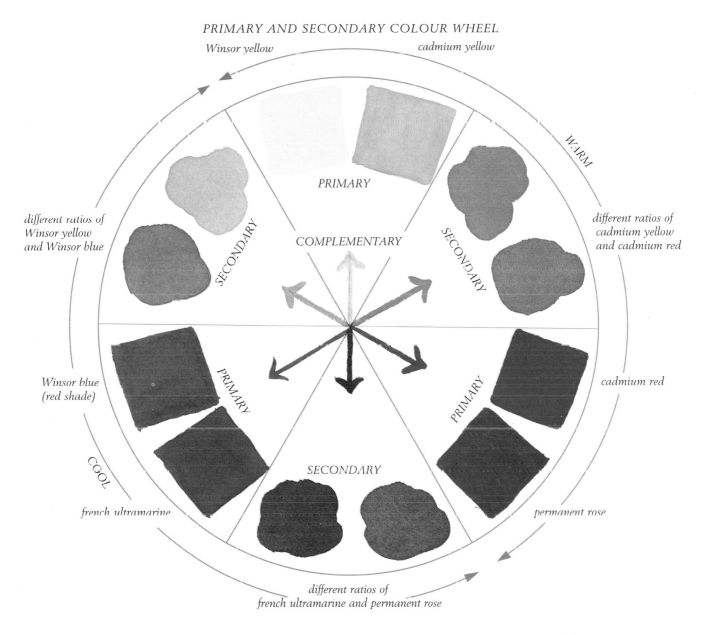

Winsor yellow

cadmium yellow

WARM

*different ratios of
cadmium yellow
and cadmium red*

PRIMARY

SECONDARY

SECONDARY

COMPLEMENTARY

*different ratios of
Winsor yellow
and Winsor blue*

cadmium red

PRIMARY

PRIMARY

*Winsor blue
(red shade)*

permanent rose

COOL

SECONDARY

french ultramarine

*different ratios of
french ultramarine and permanent rose*

understanding can only enhance your work.

The key to knowing how colour works lies in understanding *harmonious* and *complementary* colours. Most of us have learned quite early on that *red, yellow* and *blue* are the *primary* colours. *Green, orange* and *violet* are *secondary* colours, because they are made by mixing two of the *primary* colours together. Each of these secondaries is the *complementary* of one of the primary colours and does not form a part of its mix. These relationships work as follows:

> *green* (blue + yellow) is the complementary of *red*
> *orange* (red + yellow) is the complementary of *blue*
> *violet* (red + blue) is the complementary of *yellow*.

Complementary colours have an enhancing effect when put side by side; they are rather like a marriage of opposite personalities who spark off each other. But interestingly, if you need to dull down or *grey* a colour, you just add a little of its complementary colour to the mix – so I'm wondering how that works with my marriage analogy!

Harmonious colours are made by mixing gradually increasing amounts of one primary colour to another: thus red combined with yellow will make red-orange/orange/orange-yellow/yellow and all the many shades between that cannot be named precisely. They share a common link. Harmonious colours are more akin to our best friends – for the relationship to work we like them to be perhaps a little different to ourselves, but not too much.

COMPLEMENTARY COLOURS IN NATURE

It is all very well being served up a helping of colour theory but it needs to be made relevant to be palatable (or should that be palette-able?). As our subject matter is the garden there is no better way to understand complementary colours than by looking at the countless examples of flowers growing there. So, let us consider the three basic pairings of yellow/violet, red/green and blue/orange. One colour name can't begin to describe all the variants of hue and tone. When looking at a flower it is often impossible to decide where one colour stops and another begins – is that marigold a deep yellow or a soft orange? When does blue become violet? Every colour has a bias towards another, and you are bound to find that your chosen flowers do not always fit neatly into one colour category. You may have to consider the colours more analytically.

THE YELLOW/VIOLET COMPLEMENTARY PAIR

In the study of Michaelmas daisies below, the flowers can all be described as being violet with yellow centres. However, one type is much pinker because it has more red in its mix, while the other has more blue. The pinker flower has a centre that veers more towards cadmium yellow than lemon yellow, that is, a yellow with more red in it. So within the basic complementary combination of yellow and violet, this particular violet goes so well with this particular yellow because they share a common bias of colour – in this case red – so that underneath they are harmonious. In the illustration of the rose and leaf (opposite) both colours also have a red bias.

The bias in each colour need not always be harmonious to work together: for instance, the blue-violet clary sage works well with the orange-yellow golden rod because the blue is the complementary of orange. The annual chrysanthemum has petals that are more of a

▲ *SOLANUM CRISPUM*
Watercolour

*Nature has done the work already, pairing different violets and yellows in the flowers of the Chilean potato tree (*Solanum crispum*), autumn crocus (C. zonatus), Michaelmas daisies and annual chrysanthemum.*

MICHAELMAS DAISIES ▼ *AUTUMN CROCUS*
Watercolour *Watercolour*

green-yellow. The centre is a violet-brown, brown being a mix that includes some green and red. So the green in the yellow petals harmonizes with this green and complements the red. It's all quite logical really!

But, please don't become so analytical about colours that it makes you sieze up and not dare to put down a dab of paint. Analysis will help you most when you get to a point in your painting when you feel something is wrong with the colours but don't know how to address it. Meanwhile, you can happily and pleasantly sharpen up your colour sense by wandering around a garden picking flowers (perhaps just in your imagination) to make colour combinations. Then, perhaps, you can try to analyse why they do or don't look good. This constant looking is the artist's equivalent of the musician's scales; you can never do too much practice!

PRUNUS BLOSSOM
Watercolour
The prunus blossom illustrates a complex set of complementary colours. The pink blossom is enhanced by the yellow-green leaves, which respond to the violet tinges in the pink. I exaggerated orange passages on the leaves as they worked with the blue I added to the mix on some petals.

▲ *ROSE AND LEAF*
 Watercolour

▼ *CLARY SAGE AND*
 GOLDEN ROD
 Watercolour

 ANNUAL
 CHRYSANTHEMUM
 Watercolour

THE RED/GREEN COMPLEMENTARY PAIR

In this painting of *Roses, valerian and alstroemeria* I have illustrated the complementaries red and green. Pink qualifies as red, being a dilute version of it. The *blue*-red of the white-centred rose goes well with the *blue*-green of the leaf below, whilst the slightly *yellow*-pink alstroemeria looks good with the more *yellow*-green foliage.

Ultimately, what makes it all blend together is the fact that each flower or leaf is not one flat colour, but that they all borrow a little colour from each other.

Nature happily combines complementaries for us:

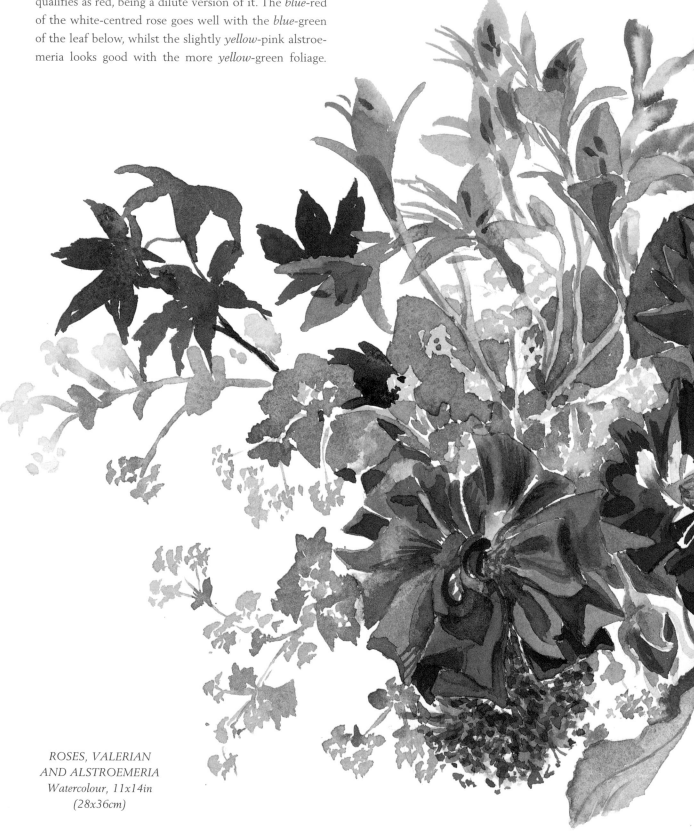

*ROSES, VALERIAN
AND ALSTROEMERIA
Watercolour, 11x14in
(28x36cm)*

the green leaves of both begonia and geranium (right) are naturally splashed with red, while the yellow-green seed-heads of an unfurling acer stand out against its glossy, chestnut-red sepals (below).

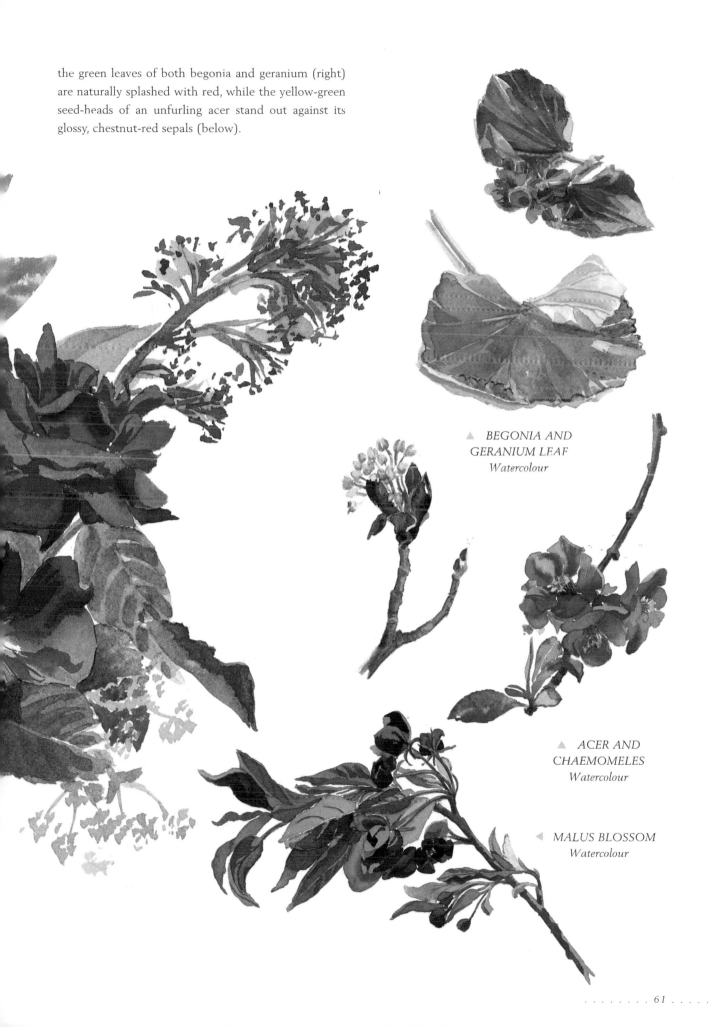

▲ BEGONIA AND
GERANIUM LEAF
Watercolour

▲ ACER AND
CHAEMOMELES
Watercolour

◄ MALUS BLOSSOM
Watercolour

THE BLUE/ORANGE COMPLEMENTARY PAIR

In *The blue jug*, blue true geraniums and nigella meet orange hemerocallis and Welsh poppies. The orange is brighter in tone and 'louder' than the blue. Therefore I used less orange to balance a lot of blue – even the jug is blue too. Much of the foliage is blue-green, with an accent of yellow-green in the leaves of the day lily. Now you try to analyse why the colours work together!

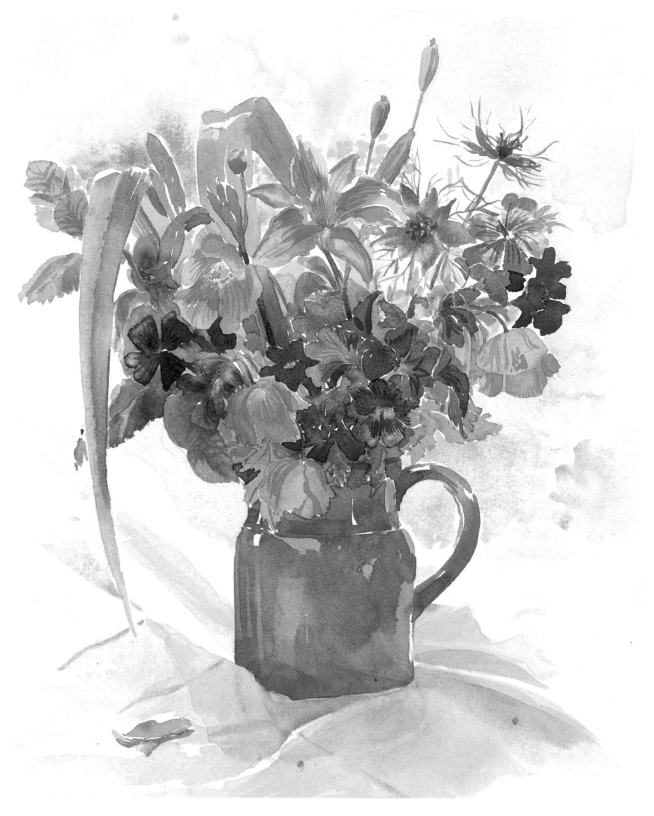

THE BLUE JUG
Watercolour, 15½x13¼in (40x34cm)

CHOOSING A WATERCOLOUR PALETTE

The next step is to try and capture on paper the colours you see. Thinking particularly of mixing paint, as children we learn that the primary colours, red, yellow and blue, are all we need to produce every other colour. But how many of us have ended up with an alluring shade of mud whilst seeking violet? This can happen because every colour has a *bias* towards another – for example Winsor blue is a *greenish*-blue whilst ultramarine is a *reddish*-blue, and it is important that we take this into consideration when choosing and mixing paints. Thus, ultramarine (*red*-blue) combined with alizarin crimson (*blue*-red) will make a good clean violet.

To allow you to mix a good range of colours, a basic palette needs to have both a *cool* (bias towards the blue end of the spectrum) and a *warm* (bias towards red) version of each of the three primary colours. I use mostly Winsor & Newton colours because of their quality. For a *basic watercolour palette* I suggest:

> *1 french ultramarine, 2 Winsor blue* (red shade), *3 cerulean blue, 4 Winsor yellow, 5 cadmium yellow, 6 cadmium red, 7 permanent rose* (this takes the place of a blue-red), *8 Rowney permanent mauve.*

I would want to augment the eight colours with three earth colours:

> *9 yellow ochre, 10 light red* and then perhaps *11 burnt sienna.*

Although not essential, I also like:

> *12 Payne's gray, 13 alizarin crimson, 14 naples yellow, 15 raw umber, 16 olive green, 17 viridian, 18 cobalt blue* and *19 cobalt turquoise.*

In this book you will find I have used all nineteen of these colours, but the basic palette of eight plus yellow ochre and light red will get you a long way and will be sufficient for the colour exercises.

On a technical level of achieving mixes, this selection of watercolours is probably not so different to another artist's choice. A 'palette' is more truly expressed on the paper in the way the painter uses colours together, and each artist has such a personal palette. This choice may stem from the way he or she objectively sees or – more likely – feels things.

BASIC WATERCOLOUR PALETTE

1 French ultramarine

2 Winsor blue

3 Cerulean blue

4 Winsor yellow

5 Cadmium yellow

6 Cadmium red

7 Permanent rose

8 Permanent mauve

ADDITIONAL COLOURS

9 Yellow ochre

10 Light red

11 Burnt sienna

12 Payne's gray

13 Alizarin crimson

14 Naples yellow

15 Raw umber

16 Olive green

17 Viridian

18 Cobalt blue

19 Cobalt turquoise

COLOUR WHEEL SHOWING MY PALETTE CHOICES AND SOME MIXES

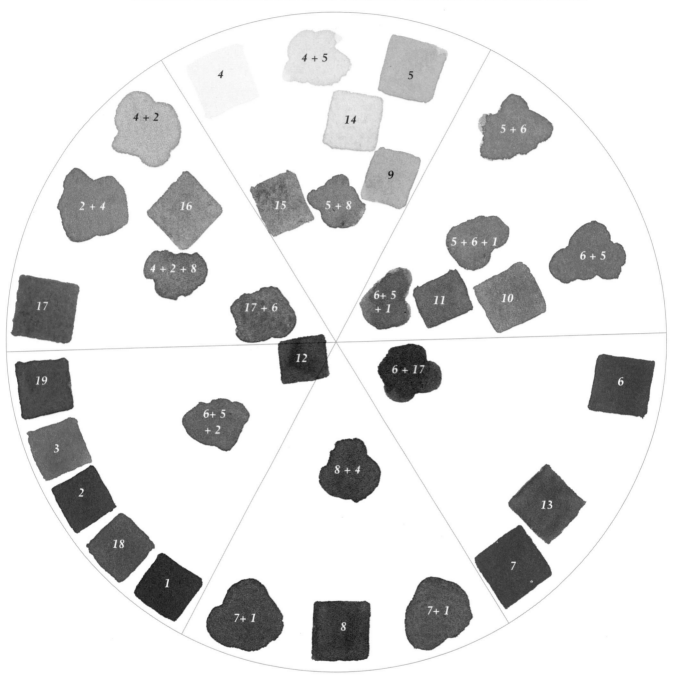

My palette choices (numbered 1–19) and some mixes are shown in position on a colour wheel. The more 'greyed' the colours, the closer they move to the centre of the circle. Mixing complementaries produces interesting earths and greens.

KEY

1 french ultramarine
2 Winsor blue (red shade)
3 cerulean blue
4 Winsor yellow
5 cadmium yellow
6 cadmium red

7 permanent rose
8 Rowney permanent mauve
9 yellow ochre
10 light red
11 burnt sienna
12 Payne's gray

13 alizarin crimson
14 naples yellow
15 raw umber
16 olive green
17 viridian
18 cobalt blue
19 cobalt turquoise

A DETAILED LOOK AT SOME COLOURS

Each colour of paint is made from a different pigment or mixture of pigments. Each possesses different properties or qualities and different pigments vary in the degree to which they are *opaque*, *staining* or *sedimentary*. Why would you want to know about any of these qualities? Well, knowing how *opaque* or transparent a colour is helps in two main ways. Greater opacity means the paint has greater covering power on the paper. The more the white paper is covered, the less light is reflected back from it, and this may lead to a duller painting. Secondly, a watercolour painting is characteristically built up with layers of paint, allowing the colour underneath to show through to some extent. So it's useful to learn about the degree of transparency of each colour in order that you won't obliterate what went before when you really want to enhance it!

Different pigments *stain* the paper to a greater or lesser degree. With the most staining pigments some colour still remains like a shadow when the paint is washed off with water. This is useful to know if you need to remove any part of your painting or if you want to use this shadow effect consciously in your work. Staining pigments not only stain paper but they also stain each other. So, for example, the very staining Winsor blue will dominate non-staining viridian – useful to know when you are making mixes.

A few pigments have a *sedimentary* (or *granular*) quality. This means that some of the minerals precipitate out when the paint is mixed with water; blues and earth colours are especially prone to this. When laid down as a wash, the result is a speckled effect, the tiny granules of pigment pooling into the depressions in the paper. This gives an attractive textural quality – sometimes more evident when certain colours are combined – which can add a lot to the interest of a painting.

I shall now consider my colour choices in detail. Except for permanent mauve, which is manufactured by Rowney, all the colours I have described are made by Winsor & Newton.

FRENCH ULTRAMARINE

This is a reddish blue. Although all blues are cool, this is the 'warmest' of them, veering towards violet. It is transparent and not very staining. It has some sediment, but it combines with earth colours to give the most wonderful granular effects.

COBALT BLUE

Slightly opaque, cobalt blue is redder than Winsor blue and greener than ultramarine. It is quite sedimentary and staining, and is nice for glazes. I like to have several blues in my palette for washes and for mixing.

WINSOR BLUE, RED SHADE (*formerly called Winsor blue*)

Although called 'red shade', this is a cool blue with a *green* bias compared to ultramarine and cobalt. It is also a real dominatrix of a colour! It stains madly everything with which it comes into contact, including paper and other pigments, so use it sparingly. Transparent and not at all sedimentary, it is a synthetic pigment that has replaced the older prussian blue.

CERULEAN BLUE

A lighter-toned, cool green-blue, cerulean is quite opaque and very sedimentary. Lovely for skies and for glazing on shadows, it is also wonderful wet on wet with permanent rose.

COBALT TURQUOISE

This is a zingy green-blue which is quite opaque – I have it just as a bit of a treat!

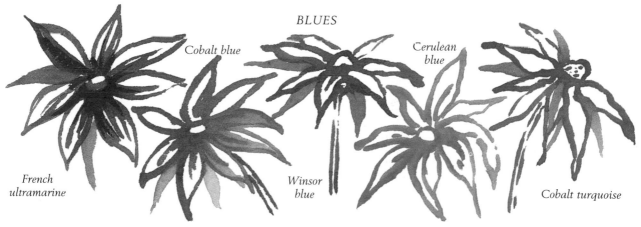

BLUES

Cobalt blue

Cerulean blue

French ultramarine

Winsor blue

Cobalt turquoise

VIRIDIAN

This is the most transparent green. Very cool – almost blue – it is marvellous for glazing over other washes. Somewhat granular, although this is more noticeable in mixing than on paper; it washes out completely without staining. However, trying to lift the pigment on to the brush from the pan drives me slightly mad – I suggest you pre-soften pans with hot water or buy it in a tube.

OLIVE GREEN

Olive is a lovely warm green which is quite staining but not sedimentary. An equivalent can be mixed but it would not be as transparent.

WINSOR YELLOW

Yellows fall into the category *warm*, but this is almost neutral in temperature. It falls on the green side of the yellows, is transparent and a little staining.

CADMIUM YELLOW

A warm, reddish yellow which is probably the most opaque of the yellows, cadmium is both slightly sedimentary and staining. Winsor & Newton have deep and pale versions of cadmium yellow; this colour is simply labelled cadmium yellow.

NAPLES YELLOW

Another warm yellow, which is 'greyed' but not so dull and much lighter in tone than yellow ochre. It has quite an opaque white base but is nice for glazes and also for rendering stonework.

YELLOW OCHRE

This warm, 'greyed' yellow (on page 72 you will see how you can mix a near-equivalent by using yellow and its complementary) is slightly opaque. It is sedimentary but leaves almost no stain. Similar in colour to raw sienna (but more opaque), it is a great basis for mellow stone walls. Mixed with blue it gives interesting opaque greens.

RAW UMBER

Another 'greyed' yellow but with a greenish tinge – quite close to french mustard, in actual fact. I suppose my predilection for these muted yellows comes from painting the limestone in the Cotswolds!

(At this point I could have a cadmium orange in the palette but I find I can mix good clear oranges easily with cadmium red, cadmium yellow and Winsor yellow.)

LIGHT RED

This is less a red and more a burnt orange or terracotta colour that is warm in temperature and useful for pots and brick walls. I often use it in mixes to make lively earth colours, and combined with ultramarine it makes a superb 'botanical grey', good for the shadows on white or light-coloured flowers. Although I list it as a supplementary colour I would be loathe to be without it. Light red is quite sedimentary.

BURNT SIENNA

This colour has the warm golden glow of caramelized orange but is 'greyed'. An approximation can be made with light red and cadmium yellow or cadmium red, cadmium yellow and ultramarine. It is transparent, slightly staining and sedimentary.

CADMIUM RED

A warm, yellowish red that has some opacity, staining power and sediment – not the one to choose for making clear violets.

PERMANENT ROSE

Warm but veering to violet, permanent rose is very transparent and staining, but has no sediment. It is a

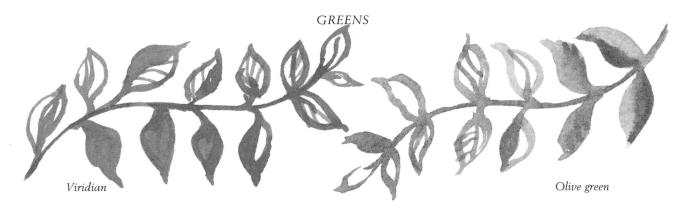

GREENS

Viridian

Olive green

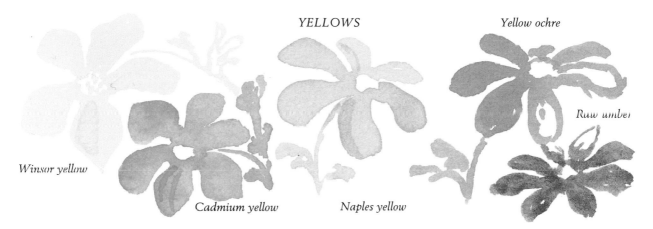

YELLOWS

Yellow ochre

Raw umber

Winsor yellow

Cadmium yellow

Naples yellow

good substitute for alizarin crimson in colour mixing as it occupies the same colour 'position' – a warm blue-red – and its particular qualities give good clear colours; it is great for making violets. Rose has had a reputation as a fugitive colour – one that fades badly. This may have been true in the past, but the use of modern pigments now ensures a very high degree of permanence.

ALIZARIN CRIMSON

This colour has the same colour position, temperature and transparency as permanent rose (which generally takes its place in my palette), but it is much more staining so be careful it does not dominate in mixes. It is also less permanent than permanent rose. It has no sediment. At the moment of writing, Winsor & Newton have introduced permanent alizarin crimson into the range. I shall be trying this out.

PERMANENT MAUVE (ROWNEY)

I use this as a glaze instead of blue for slightly warmer shadows in mixes. It also helps to produce earthy greens and lively greys. This colour replaces my original choice of Winsor violet 728, which has now been discontinued but can be reproduced by mixing Winsor violet dioxazine with Winsor & Newton permanent magenta.

Permanent mauve is slightly redder than Winsor violet 728, but seems to work effectively in mixes.

PAYNE'S GRAY

This is a clear blue-grey and is quite cool. It is very useful for darkening blues, for stormy skies or as a dark wash for shadows. A substitute can be mixed from Winsor yellow, permanent rose, Winsor blue and ultramarine.

All these colours, except the alizarins, are A or AA rated, which means that they have been made to be colours that are permanent for artists' use and can be mixed safely with other colours of the same rating. The earth colours are among the most long-lasting. Alizarin crimson is classed B – a moderately durable colour – whereas permanent rose is A, so you can see that the latter is a good alternative in terms of both colour mixing and permanence.

All this information may seem like a terrible block to creativity, but with hands-on practice – like learning to drive – it will soon be absorbed and used automatically. I am always surprised how quickly, with practice, new painters can move from 'Which one is the Winsor blue?' to 'That green looks like a combination of ultramarine and Winsor yellow to me'.

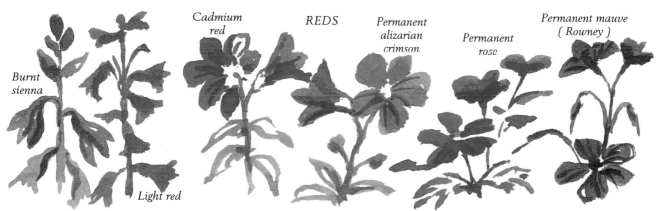

Cadmium red

REDS

Permanent alizarian crimson

Permanent rose

Permanent mauve (Rowney)

Burnt sienna

Light red

CHOOSING A PASTEL PALETTE

Selecting pastels is more of a challenge than choosing watercolours. With watercolour, a small range of colours can be mixed to produce a huge range. This is not true of pastels, so most pastellists have an extensive range of colours. There is a huge and bewildering choice of hues on offer and, as explained in the section on materials, each manufacturer's pastel has a different character as well as colour. You can find very similar hues made by different manufacturers but they are identified by each maker's unique naming system. I shall give you my personal suggestions, but really you will need to try everything for yourself.

You could begin, as we did with the watercolours, by following the simple rule of choosing a cool and warm version of each of the three primary colours. You would also need to add cool and warm secondary colours. After that you will want lighter, darker and greyed versions of these colours – and you can see how easy it is to end up with hundreds.

Bearing in mind our subject matter, a good start may be to buy a boxed set of landscape colours which you can then augment with further greens and some bright hues for flowers. It's a bit like the chicken and the egg: until you decide on exactly what you want to paint, you can't easily select colours. Having a subject in mind is probably the best way to begin. I have selected a small range of pastel colours for the step-by-step painting of hyacinths (pages 113–15) to show how few you might need: in fact, in this example they weren't even the 'actual' colours, as I changed a blue hyacinth to white and warm greys in order to raise the temperature of the palette. Making a small selection can imbue a painting with a sense of harmony. And remember that a colour can look entirely different depending on the hue next to it, or the proportions in which it is used. Never feel limited by a small selection – try to go with the architectural adage 'less is more'.

PERSONAL CHOICES

I believe that everyone has a 'personal palette' of colours that they instinctively use in everyday life – or at least

some colour preferences. When you go to the shop to choose from the tempting array of pastels, indulge these preferences. You will probably find that the subject you want to paint will include those colours because you have an instinctive attraction to them. It is important to enjoy the whole process.

My personal selection, bearing in mind the subject of gardens and flowers, is inevitably weighted towards greens, yellows and earth colours. And with flowers in mind there are a few vibrant reds, pinks, purples and oranges. Blues, violets and greys are important for shadows, and useful for softening strong hues or changing their tones. The choice of greys in pastel is vast but I find the warm greys particularly useful.

Although I may use many more colours, I have illustrated on these pages a selection of colours I use regularly for garden themes and flower pictures.

I don't pretend to understand what influences lead us to our personal palette. My soft spot is for the colour violet, which I use a lot in shadows and colour mixing. I try not to impose my preferences when teaching but I

hear myself suggesting 'a bit of violet' here or there, and then a groan of recognition goes up from the class! I have sometimes felt I was indulging – a shameful habit, but then I discovered that the painter Winifred Nicholson (1893–1981), who favoured domestic landscape and flower themes, also explored the virtues of violet. I have always felt that it is a colour which both completes and continues the visible spectrum – it is the rainbow's last band and bridges the gap between cool blue and warm red. Like Nicholson, I believe colour is not only to be viewed through the intellect. To quote her:

...very, very tentatively one may speculate that the research of colour may investigate into the abstract quality of our emotions...

She was aware that ultra-violet lay beyond visible violet and believed that one day we might see colours that exist beyond the present limitations of human sight. Whatever you feel about this, it reinforces my opening point that painters express themselves through their use of colour.

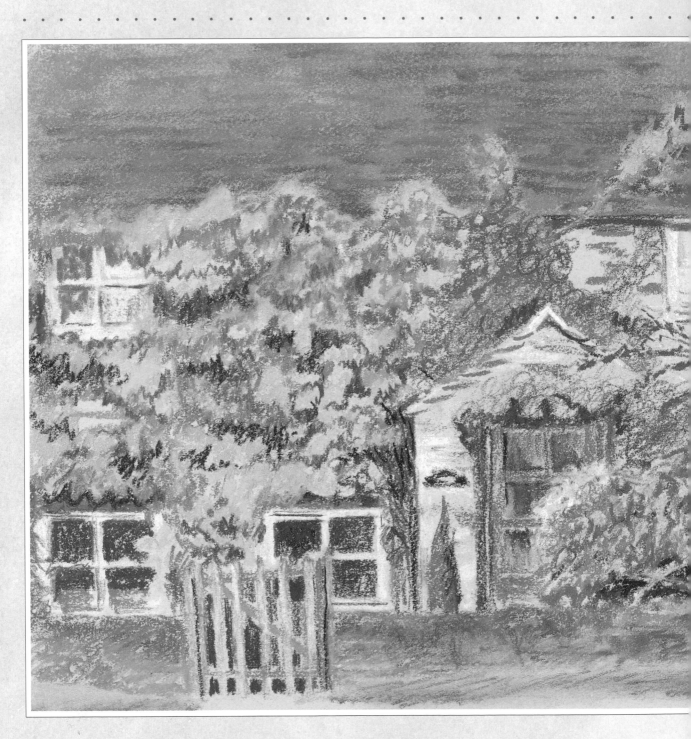

TECHNIQUES &

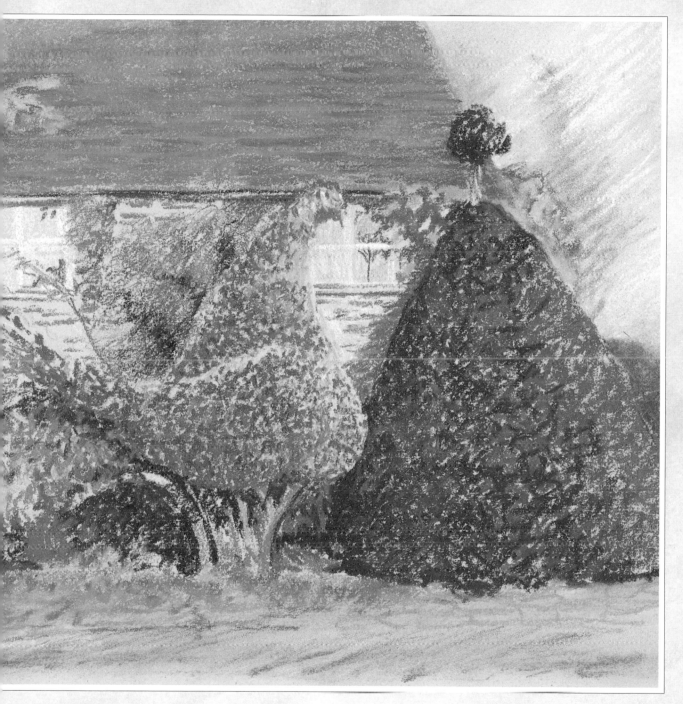

APPROACHES....

WATERCOLOUR

AN EXERCISE IN COLOUR AND TONE

It is now time to lay hands on your equipment and try out some ideas for yourself. Having looked at colour theory, we must now combine these ideas with our sketchbook explorations of tone. In any painting it is the contrast of tonal values that gives the illusion of light: if these values are too close the effect is flat, no matter how bright the colours. So how do you put down on paper that crucial lightness and darkness when you are being totally excited (and confused) by the colour in front of you?

When the tonal values aren't working in one of my own paintings it is often because my attention is being distracted by lots of colour. A first step to improving things is to limit severely the number of hues I am using. Now and again I will give myself the discipline of an exercise like the one that follows. It is amazing that such a large range of tones and hues can be produced using only two complementary colours. And because you begin by using two colours that work together right from the start, the resulting painting has a natural harmony and coherence. This exercise should help you to analyse the tonal values of the colours which you produce and show you how many new hues it is possible to achieve by mixing just two colours.

USING COMPLEMENTARY COLOURS

I decided to use the close complementaries cadmium yellow and Rowney permanent mauve to paint the flowers opposite. My immediate response was to choose the cadmium yellow to represent the lightest tones because it is obvious that, inherently, violet has a much darker value. However, the beauty of watercolour is that the tone of all colours can be changed by dilution, so it would not be impossible (though it might be difficult) to let the violet represent the lightest values.

First, paint bands of the two colours, trying to match their tones. A good way to see if you have succeeded in getting the same values is to look at them through screwed-up eyes. Alternatively, take your paper to a place with a dim light source and it will be obvious which is reflecting more light. If you use the colours straight out of the tubes diluted with as little water as possible there is no way the yellow can be as dark as the violet. You need to dilute the violet considerably so that it becomes lighter by 'borrowing' reflected light from the white paper below it. The yellow, although just as light in tone, has completely obscured the paper. Cadmium yellow is an opaque pigment and goes onto the paper in a very smooth, even fashion. As you become familiar with more colours you will be able to take into account the way the different pigments behave.

Now, bearing in mind the way in which the tones are affected by their dilution, choose a subject to paint from life. In my painting the colours are used unmixed in a variety of dilutions, and also mixed together to produce new hues and tones. In Chapter 6, I described the way that colours can be 'greyed' by mixing a little of their complementary colour with them. Adding just a little permanent mauve to cadmium yellow produces a greyed yellow, not unlike yellow ochre although yellow ochre is slightly less opaque. Raw sienna, very similar in hue to yellow ochre, is even more transparent. So you can see that while there are many ways to achieve a particular colour, the effect on the paper may be slightly different. As you continue to mix more permanent mauve to cadmium yellow, subtle reddish browns turn into greyed red-violet. Using mauve at full strength you are able to produce the darkest tone. This exercise has demonstrated that by using the right two colours you can produce a rich palette, ranging from very light to very dark in tone, and of warm temperature.

(pages 70–1) TOPIARY BIRD Pastel, 10x21in (26x54cm)
With pastel I was able to create texture and optically mix colours for an interesting effect. The painting proved far more exciting than the photograph I took, which flattened all the foliage into two or three sombre tones of green.

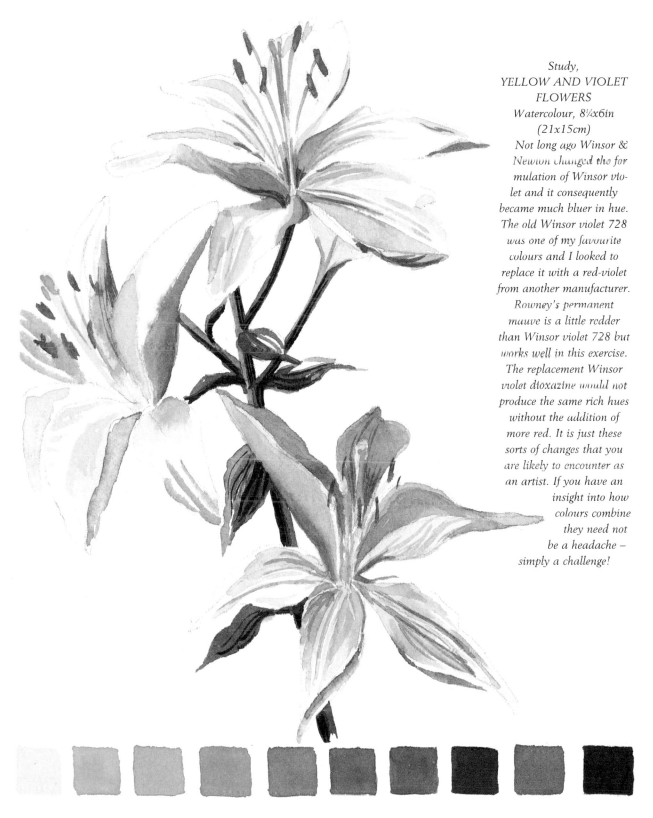

*Not long ago Winsor &
Newton changed the for
mulation of Winsor vio-
let and it consequently
became much bluer in hue.
The old Winsor violet 728
was one of my favourite
colours and I looked to
replace it with a red-violet
from another manufacturer.
Rowney's permanent
mauve is a little redder
than Winsor violet 728 but
works well in this exercise.
The replacement Winsor
violet dioxazine would not
produce the same rich hues
without the addition of
more red. It is just these
sorts of changes that you
are likely to encounter as
an artist. If you have an
insight into how
colours combine
they need not
be a headache –
simply a challenge!*

Try this with the near-complementaries ultramarine and burnt sienna (a greyed orange), or olive green (greyed yellow-green) and cadmium red. The latter produces lovely colours for lichen-covered brick walls and terracotta pots. Experiment as much as you can with colour mixes. Make your own judgements about what is pleasing, and don't worry if you mix up a lot of mud on the way! Like a map, I can only guide you; I can't show you every stone on the path. To quote from the Veda:

*Learning from books and teachers is like travelling by
carriage. But the carriage will only serve while one is
on the high road. He who reaches the end of the high
road will leave the carriage and walk on foot.*

*Viridian +
Permanent rose*

*Ultramarine +
Winsor yellow*

*Olive green +
Permanent rose*

Winsor yellow + Winsor blue

MIXING GREENS AND EARTHS

In the exercise on pages 72–3 you mixed up a colour similar to yellow ochre in *hue* but not *opacity*. As watercolour painting depends to a large degree on the light that is reflected back from the white paper through the colour washes, so the transparency or opacity of the paint are important factors. Because our subject is organic, it will be as well to know how to mix up some relevant colours.

When listing colours for the palette I suggested olive green as an addition, also mentioning it was a short cut that prevented me having to mix my own. This is not entirely accurate: you certainly can mix similar colours, but their characters are entirely individual. Looking at

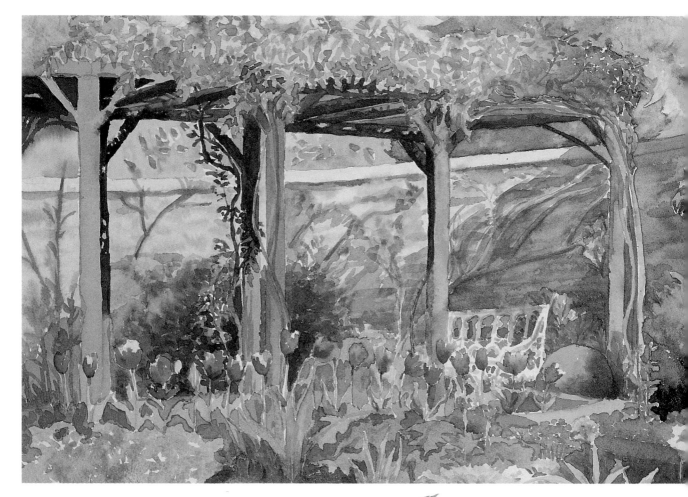

*Cadmium red+ Cadmium
yellow + Cerulean*

*Cadmium red+ Cadmium
yellow + Ultramarine*

*Cadmium yellow +
Viridian*

Viridian + Winsor yellow

Cerulean + Winsor yellow

Winsor blue + Cadmium yellow

Winsor blue + Cadmium yellow +Permanent mauve

Olive green + Permanent mauve

the examples, *a* is olive green from the tube, *b* is a mix of viridian, Winsor yellow and permanent rose; and *c* is Winsor blue with cadmium yellow: *a* has the quality of a warmish yellow-green that is a little greyed and has a slightly granular appearance on the paper; *b* is really very similar but the graininess is more pronounced, and the bluish pigment from the viridian has settled into the

depressions in the paper giving this colour a cooler cast; and *c* has a smoother appearance because of the quality of the cadmium yellow pigment. It also looks 'flatter' as the cadmium yellow is so opaque it has obscured the reflective white paper. This may seem like nit-picking but this kind of knowledge is of use. You might, for example, wish to modify a colour you have laid down with an over-wash of olive green. If you choose *a* instead of *c* you will end up with a final colour that is more reflective and less dull.

For reference I have mixed up green and earth colours on these pages which may be of use to you when painting garden subjects.

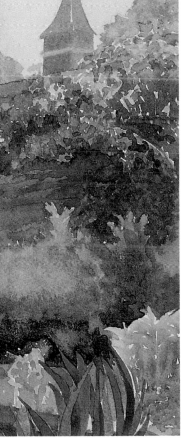

ROSE GARDEN IN SPRING
Watercolour, 10x18¾in
(26x48cm)
The greens used here were predominantly made from different mixes of viridian, Winsor blue – red shade, ultramarine and Winsor yellow with the addition of some cobalt and yellow ochre. In places a red violet has been added to 'grey' the greens.

a *b* *c*

Cobalt turquoise + Winsor yellow

Cobalt blue + Winsor yellow

Yellow ochre + Winsor blue

Cadmium red + Cadmium yellow + Winsor blue

LAYING WASHES

Most books on watercolour tell you how to do a wash. Certainly the consummate skill of the eighteenth- and nineteenth-century English watercolourists showed in their ability to lay down a wash which was so even it sometimes looked like printed colour. I very rarely use a single-coloured flat wash to cover large areas. Mostly I build the painting with small areas of colours, bit by bit. The white paper is very important to me and I reserve it until I have to paint on it. Nevertheless, I find it useful to have as many techniques as possible available to me, even if I do not use them often.

EVEN WASH

I use this sort of wash rarely, an exception being the painting *Herbaceous borders, Langwell* done in a garden in Scotland. I laid a very pale pink (light red mixed with permanent rose), even wash over the whole of the paper. This was because my first glimpse of the garden had given me a strong impression of candy floss! After a hot summer, all the grass paths were parched, bleached to a pinkish-yellow, and the most dominant planting was floating sidalcea, tritonia and filipendula in rosy shades. The wash was allowed to dry completely before over-painting. Subsequent washes of colour were then modified by this pink underpainting which acted as a unifying factor; the highlights, too, were created not by the white of the paper but by this very soft pink wash. The sky was overcast, but the cloud was thin and high so that the light was bright but rather 'flat'. This warmish, even wash gave just the right effect, as well as linking the sky by colour with the rest of the painting.

To apply a successful, even wash you need to mix up enough paint of one colour in a dilution that will flow gently across the paper surface rather than being inert or running uncontrollably. If you run out half-way through, the paint may begin to dry on the paper while you are desperately mixing more wash, so you are unlikely to produce an even spread. The key to applying a perfect flat wash is having plenty of wash and lots of confidence. Choose a nice fat brush – a good reservoir for paint. Place your board at a *slight* angle so that paint can flow down towards the bottom of the paper, and let your loaded brush travel back and forth horizontally across the page. The rate of travel and the pressure of the brush should be constant. Each 'row' of paint must connect gently with the one above so they flow together. Excess paint that gathers at the bottom edge of the wash should

be mopped up with a clean, just-damp brush.

If you make a horrible blob at any time *don't* stop and fiddle with it. Keep going: you are going to have to live with less than perfection and there's always a next time! And rather like not going back into a burning house, do not attempt to go back over mistakes when they are dry or drying – you will make them ten times worse. Personally, I like to think of mistakes as fateful; you often find that if you integrate them happily into the end result they actually add something to your painting.

BROKEN WASH

This wash is as it sounds: the brush is lifted on and off the paper, leaving some areas unpainted. Very often only little pinpoints of white paper are left, but these can give an enlivening sparkle to a flat area of colour. A broken wash is evident on the end wall of the house in *The dove-cote border* on pages 12–13.

GRADUATED WASH

This is a wash which goes from light to dark (or vice versa) simply by controlling the flow of paint from your brush. Laying a good wash demands just the right combination of time and pressure. The quicker and less heavy-handed you are, the more delicate your wash; and by slowing down and letting the paint pool on the paper you create a darker area. I find it easier to begin with the light-toned area first so that I move from a fast and light application of wash to a slower and heavier one. With practice you will discover the method that suits you best. You can also lay down a strong pool of pigment and with a rinsed, damp brush, shade it out across the paper so as to create a lighter tone at one end.

HERBACEOUS BORDERS, LANGWELL
Watercolour, 17½x11¾in (45x30cm)
A pale pink, even wash was applied first over the entire paper and this pro-vided a unifying effect.

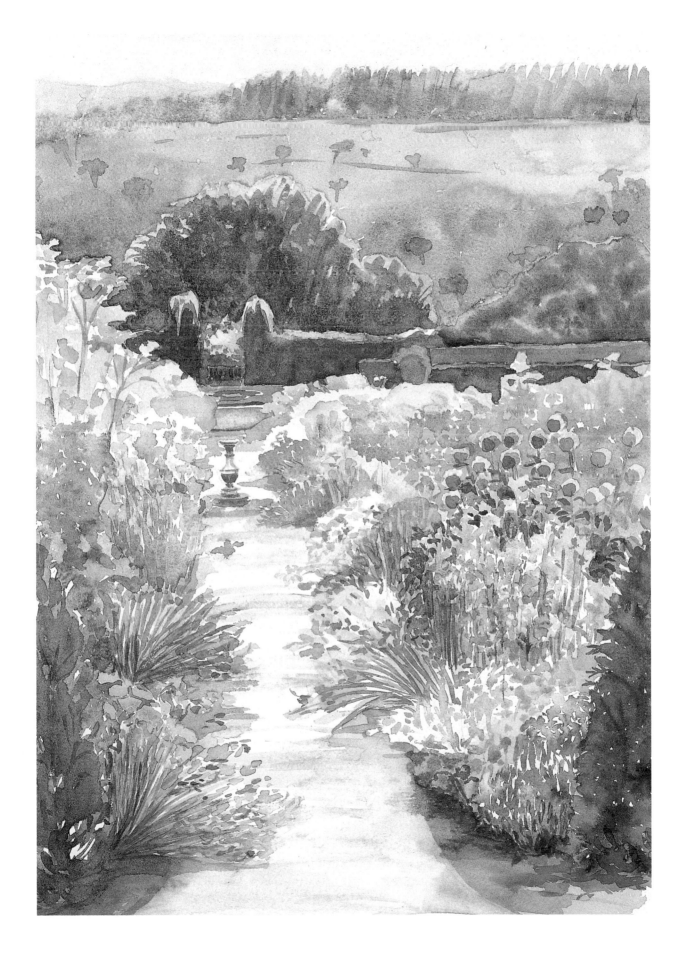

VARIEGATED COLOUR WASH

The washes described so far have used only one colour of paint. The variegated wash introduces more colours. The classic way to achieve this effect is to mix plenty of the two or more colours that you want to use, then to proceed as you did for the even wash, laying down rows of paint and allowing them to flow into one another. But instead of using a single colour you use two more and allow the different colours to intermingle. They barely have to touch each other before they begin to flow together. If you just drop one colour rather heavily onto another you will get a very different effect (see wet on wet, page 80). You need to imagine the colours as two young lovers having their first chaste kiss!

To produce a variegated colour wash I often rapidly mix another hue into the basic wash on my palette. I apply the new mix to the paper quickly, allowing the colours to intermingle as before, making sure the paint I have already laid down has not begun to dry. I keep mixing new colours with water and laying these onto the paper alongside the existing still-wet colour. The disadvantage is that it is not easy to get back to the colour of the original wash. The advantage is that it does not take up too much space on the palette, because as fast as you

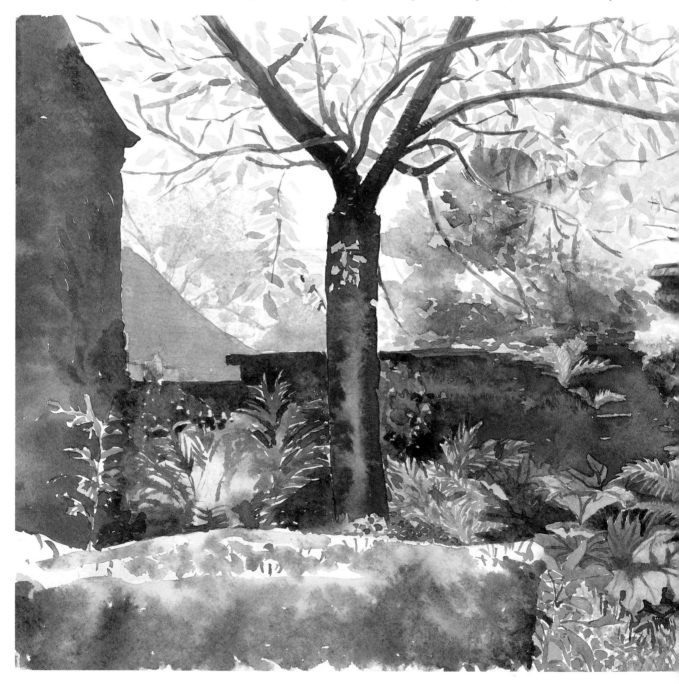

make a new colour mix you use it. This is an important consideration when you are outside and using a portable tin of paints with only a small integral mixing area. I also like to make a variegated wash in this way because a subtle variety of hues can be applied in a random way. The end wall of the house in the painting *Cherry tree* was mainly applied in this way, as was part of the background to *Lilacs*, page 83.

APPLYING A WASH TO A SHAPE

This technique is ideal for painting the representational parts of your work such as trees and plants, and flowers

▶ *'SILVER JUBILEE'*
ROSE
(detail)
Watercolour

in particular. It allows you to define your subject without making it look as if it has a border all round with the middle filled in afterwards. Once again, success has a lot to do with the speed at which you work.

When applying a wash to a small shape I start by defining the top edges with the tip of my brush. I do not linger too long around these or they will begin to dry and create the border effect. So working quickly and downwards, I 'pull' the wash into the centre of the area and come to rest along the bottom outlines. The wash can be even or graduated, depending on how I vary the pressure of the brush – and variegated if I dip my brush into new paint along the way.

HARD AND SOFT EDGES

The techniques described above in 'Applying a wash to a shape' produce quite a crisp edge. If I want to produce an area or shape with softer edges I can do this in two ways. The first method is to begin in the centre of the shape with a strongish paint mix, and gradually add more water (or water and ox gall) with my brush as I move out towards the edge of the shape, letting the colour flow over any drawn lines. Alternatively, I make a very dilute wash and drop it liberally over the shape, including its outline. When this has dried to a certain degree of dampness, I add a stronger paint mix to the centre of the shape. The paint flows by capillary action towards the edges of the previously painted area. Only experience can tell you the right time to apply the second wash – and remember this will change with the weather! Outdoors you may have to work superfast when the hot sun dries everything quickly, while on a damp day you may have to wait for ages.

◀ *CHERRY TREE*
Watercolour, 13½x18¼in
(35x47cm)
In this picture the end wall of the house is painted with a variegated wash; the first wash on the tree trunk was also variegated – further light red was then added wet on wet.

WET ON WET

I love this technique because it nearly always produces surprises. Its name describes the technique exactly; you drop wet paint onto a first application of wet paint before that has had time to be absorbed significantly into the paper. 'Dropping' is the operative word, and as I am not on video I have to counsel you to experiment with different dilutions of paint. Try cerulean and permanent rose, or ultramarine and burnt sienna, which produce marvellous granular effects when dry. This isn't the time to worry about even washes – enjoy the texture created by watermarks and pooling pigment.

DRY BRUSH

This is a technique I use occasionally – but my nature is wet rather than dry! A dry, or nearly dry, brush is dipped into a small amount of not-very-dilute pigment and dragged lightly across the paper surface. The stroke continues until the paint runs out, creating tracks and highlights, because some areas of paper are missed. The effect is random and textured, and the rougher the paper the more texture will be revealed. I might use a dry brush to portray a grassy area with the light sparkling on it. A flat bristle brush is particularly effective for carrying out this technique.

▲ *Study,*
OVERPAINTING
Watercolour, 6x8in (15x21cm)

OVERPAINTING

Have fun on a rainy day and use your watercolour selection to experiment with overpainting. Simply paint a reasonably sized patch of each colour onto some pages of your sketchbook. When dry, paint your colours over each patch to see how they affect each other and which are more transparent or opaque. After using 'straight' colours, go on to do the same with different mixes and dilutions.

I often try to achieve the tone I want with one wash, as fewer washes seem to produce a cleaner end result. This is not always realistic, nor is it always desirable: for instance, in the painting *Dunbeath Castle garden* on pages 84–5 I achieved a very different effect by putting a grey wash over a damp, pale cadmium ground than I would have if I had mixed the cadmium into the grey wash. If you can't get to your desired depth of tone in one wash, overpainting with the same colour efficiently builds up tonal values, as you can see in this example.

REMOVING PAINT

Sometimes if I have been too heavy-handed and the tone is too dark, I blot the work immediately with tissue or a sponge to remove the paint. This can produce a nice uneven texture which adds life to an area. This technique can be used to great effect to lift out areas of cloud in a washed sky. If I don't want a texture, I lift off the paint more evenly with a rinsed damp brush.

GUM ARABIC

The addition of gum or gum-water (gum diluted in the painting water) makes the paint more viscous and so controls its flow to some extent. This can be useful when

◀ *MARGUERITES ON BLUE*
Watercolour, 11¾x12½in(30x32cm)
The blue background was painted wet on wet, as a foil to the more precisely rendered flowers.

using a wet-on-wet technique. It also makes the paint more translucent, revealing more of the underlying colour without making the mix too wet. It is useful when you want to add a final *glaze* to your painting. But beware: if you try to overglaze a paint layer which has a high proportion of gum in it, you will find it lifts off the paper too easily. However, this can sometimes be used to positive advantage. If I am not feeling courageous and need to add a final area of wash which might 'make or break' the whole painting, I will probably mix it with gum – I then have some chance of altering or removing it if it is wrong. Gum can also be used intentionally as a 'resist', as described below.

At this point I should, perhaps, define my use of the word *glaze*. It is generally used to describe the over-painting of translucent layers of oil or acrylic paints, which are mostly used in an opaque fashion. It is not normally used in relation to watercolour, where one transparent layer of paint is added on top of another. However, as I often build up areas with small brush strokes I use the word glaze to mean a generalized colour wash over previously worked detail.

Using gum arabic in colour laid directly on white paper can give vibrant results. Remember that the translucent quality of the paint is increased – this means that paint mixed with gum does not have the same potential for creating dark tones if used directly on white paper. It does, however, produce a lovely shine, and this reflective quality can be exploited in dark areas of your work which have become dull and tired from too much overpainting. Dull passages can be rejuvenated with a glaze of gum-water (beware of undiluted gum because it may crack when dry).

I used gum arabic for the work *Late summer flowers* on pages 38–9. It invested the pinks of the hemerocallis with a vibrant sparkle, and even though I was working on a small scale when painting the intricate details of individual flowers, I was able to use the paint quite wetly and loosely because the gum helped to control its flow.

In the painting *Lilacs*, I used gum in the mix for the ceramic pot so as to convey the hard, shiny surface. The solubility of the gum allowed me to lift off areas of paint that had over-run, particularly at the edges, and restore the white paper beneath.

Gum arabic can also be used as a kind of resist to produce highlights. The procedure is simple. Apply a wash of ordinary watercolour paint and allow it to dry. Then apply another wash mixed with gum and let this dry.

With a fine, clean brush, paint water onto the areas you want to highlight. (For a more random effect you can flick on the water with a decorator's brush or tooth-brush.) After a few seconds, blot the wetted areas with tissue or rag to lift off parts of the more soluble gum wash. The highlights now stand out well against the remaining rich gum-paint mixture.

This method can be used on white paper to create white highlights. I could have used it to create the white of the petals in *The laburnum lawn* (pages 86–8), and in fact, the effect might have been more random and natural. I didn't choose this method because painting over a gum wash would have been more difficult and would have produced a different finished appearance. I think gum arabic is an undervalued additive, so please experiment for yourself.

MASKING FLUID

I use masking fluid occasionally. It does have its uses, but masked-out areas can end up having very hard edges, and I find this a major drawback. Handling sticky latex even on the finest brush can be a somewhat blobby affair, so masking out very detailed shapes is difficult. I would use it for preserving small points of light in a wash – see *The laburnum lawn* – but I very rarely use it to mask out a foreground in order to put a background wash over it. I like to paint my backgrounds at the end, working carefully around the main subject. Beware of leaving masking fluid on the paper for too long as it can be very difficult to remove, especially if you have exposed it to heat. I have had to abandon many brushes in the past because they became clogged with masking fluid and useless – now I clean them quickly with white spirit, followed by water and washing-up liquid.

DUNBEATH CASTLE GARDEN

In the painting of *Dunbeath Castle garden (pages 84–5)* in bleak Caithness I wanted to contrast the lush, protected walled garden with the wild grey sea beyond. I composed the picture in two almost equal halves divided horizontally to show the contrast between the two areas. The castle bridges the two sections. The dark foliage on the back wall near the castle and the fore-

LILACS
Watercolour, 16x12½in (41x32cm)

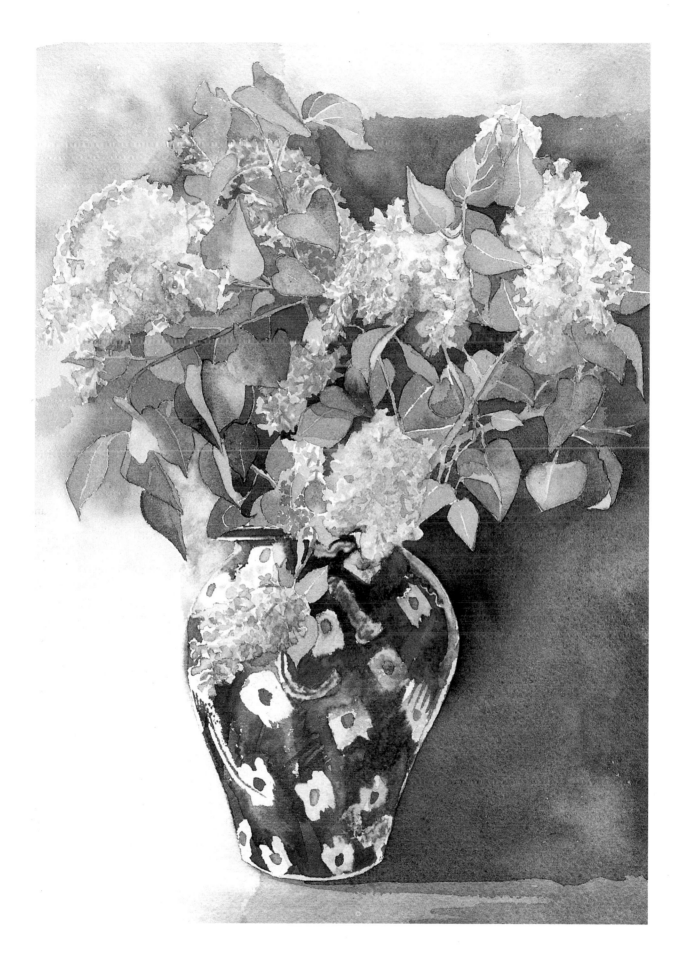

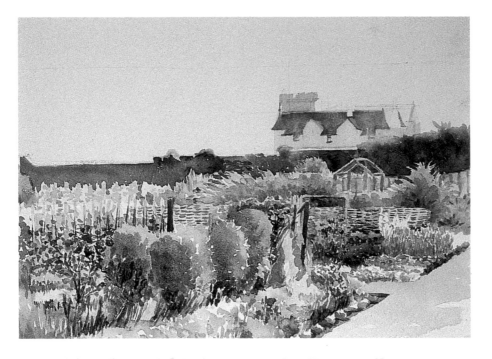

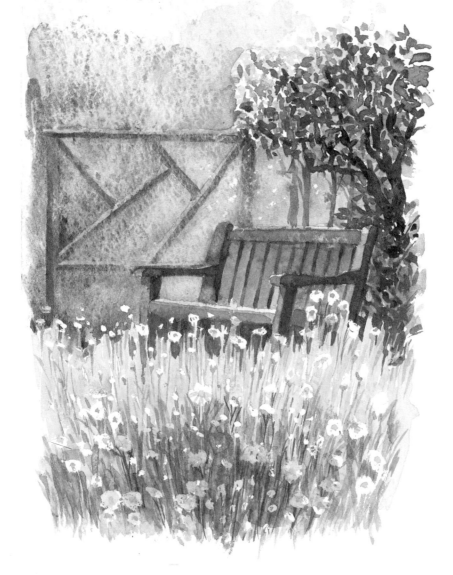

▲ DUNBEATH
CASTLE GARDEN
*Watercolour, 12x15½in
(31x40cm)
Stage one: On location I
concentrated on capturing
the planting in quite a con-
sidered, meticulous style.
Stage two: It was easier to
use masking fluid in the
studio, which is where I
painted the sea from
sketchbook studies.*

◀ BENCH AMONG
DAISIES
*Watercolour, 12¾x8½in
(33x22cm)*

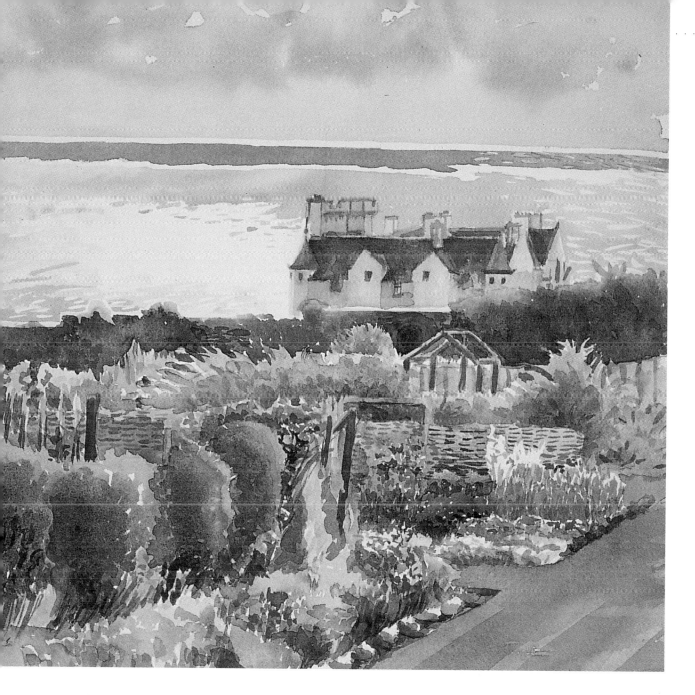

ground green bushes create a diagonal axis across the painting. The eyes then lift up to the bright lime-coloured vines, spotlit by a shaft of sun, and on up to the sea. I was a bit heavy-handed on the tone of the fore-ground bushes and castle roof, so I used a damp brush and tissue to blot off excess paint. Most of the garden was painted on location but the sea was painted from sketches made at the time.

Using masking fluid, I masked out the bright horizon line and the small areas of white-caps on the sea to the far left and right; I then painted a loose grey wash over the top. (The mix was noted in my sketchbook.) A large white area was left in the centre where the light reflect-ed coldly and sharply. For the sky I put down a very pale wash of cadmium yellow, and while it was still damp I washed over it evenly with the same mix as I had used

for the sea, working from the horizon line upwards. While this was wet I dropped in more of the same mix, wet on wet, at the top of the sky to produce the clouds.

When everything was dry I felt the garden and the sea were too divided by temperature – the sea was too cool and the colour did not link it to the garden. So, finally I added a very pale, broken wash of olive green over parts of the sea to harmonize it with the garden.

I used masking fluid for the daisy heads in the paint-ing *Bench among daisies*, building up fine strokes of colour over and over again for the stalks. This very heavy, rough paper enhanced the granular effect of the back-ground washes. I applied these and washed them off with copious amounts of water several times. I created some small highlights of floating pollen by scratching the paper surface with a knife.

THE LABURNUM LAWN

This watercolour was painted after an initial sketch (see page 42). The attraction of the subject lay in the colours and shapes. The yellow and violet complementary colours of the planting worked well. In fact, the cushions of plants and the sprinkling of laburnum petals upon the lawn reminded me of the rich pattern of a medieval *mille-fleurs* tapestry. Curves are repeated throughout the composition: in the alliums, the vegetation, the lawn and the gates. I exaggerated the circular clumps of foliage on the background tree in order to echo this theme.

I like to keep as much of the background paper white for as long as possible, so I rarely lay down large washes and then paint over them. My method is more like doing a jigsaw puzzle: one piece follows another, with careful adjustment if it proves to be not quite right! I believe that preserving as much white paper as possible until the last minute gives a sparkle to the finished painting. I keep in mind the sage advice his carpentry teacher gave to a friend of mine: 'Keep your wood as long as you can, as long as you can'.

I generally begin with what interests me most, or with an area which is likely to change as the light moves.

*THE LABURNUM
LAWN
Watercolour, 13¼x13¼in
(34x34cm)*

DETAIL 1

In *Detail 1* the yellow of the laburnum and the yellow-green of the standard wisteria caught my eye and seemed to be focal points. Then I painted the shadows on the alliums as my first record of the light. The spindly plants with green heads beside the wisteria caught the light and stood out against the shaded wall. To give this lit effect I painted them first, leaving a narrow border of white around their stalks as I carefully painted the wall behind. Each foreground mound of planting was given a wash representing its lightest tone, and brush strokes were then added to suggest the texture of the different leaf forms. The background foliage was described in less detail, and the further it receded the lighter in tone it became.

In *Detail 2*, I began by painting the laburnum with a mix of Winsor yellow and cadmium yellow, and its foliage with a mix of Winsor yellow and ultramarine in various proportions applied quite wetly. Using a brush, I placed blobs of masking fluid where the dropping petals were to be and left it to dry. With Winsor yellow, ultramarine and a little olive green applied wet on wet I painted the first mixed wash on the evergreen tree. The front hedge was given a dilute wash of Winsor yellow and ultramarine with a little cadmium yellow and violet mixed in. When it was dry I laid a second wash of the same mix. By now the masking fluid had dried, so I

DETAIL 2

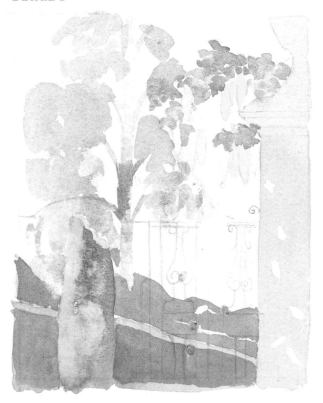

painted this gatepost with a first wash of yellow ochre and light red. Because the light was softly filtered through clouds, I relinquished the white paper and gave the sky area beyond the gates a very dilute wash of yellow ochre and cadmium yellow. When the background was dry I painted the tree with a mix of cerulean, Winsor violet 728, Payne's gray and yellow ochre, dabbing occasionally with a piece of tissue.

The lawn area (*Detail 3*) was left until last as it was one of the lightest areas in the painting. I wanted to retain some of the white paper so that this area would sparkle. To create the effect of the petals on the lawn I dabbed on masking fluid with a small brush and allowed it to dry. I mixed a dilute wash of Winsor yellow and ultramarine and laid that over the lawn area; some areas

DETAIL 3

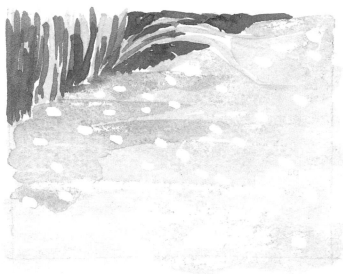

were given a couple of washes. When the lawn was thoroughly dry I rubbed off the masking fluid with my finger tips and dotted in cadmium yellow for the yellow petals, but I did not obscure all the white completely. A final very dilute wash of Winsor violet 728 and light red gave the soft shadows to the edge of the border.

In the final painting the gatepost is strengthened with the original wash of yellow ochre and light red in different mixes and dilutions. To give the effect of stone blocks, I left the mortar joints as a single wash. The shadows required a third or fourth wash. Further washes on dry paper were added to both trees, and when everything was dry the gates were painted in with a finer brush. I never use black, and this dark grey was probably achieved with Payne's gray mixed into one of the green washes on my palette.

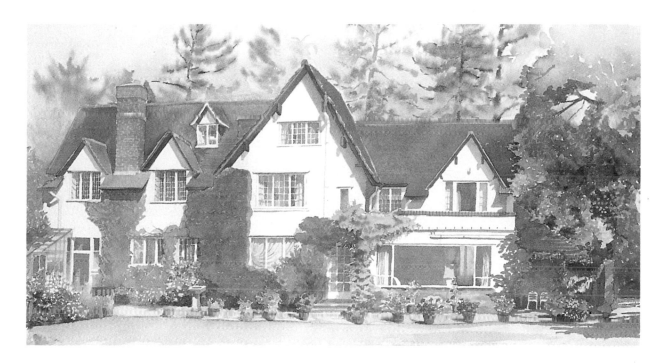

BACKGROUNDS

As mentioned before, I don't start by laying down a broad wash for the background – a method you may have been recommended by other artists. I like to add the background carefully after, or during, the painting of the main composition. In *The Barff* I used the white paper to represent the white paintwork on the walls. I wanted to balance the white façade with white areas elsewhere and so allowed the washes to taper out in the sky and in the foreground, leaving the white paper exposed. After completing most of the house, a random but fairly even pale blue wash was applied above the roof line. While this was still damp, the green pines were painted in, creating a soft, slightly out-of-focus effect to contrast with the crisper portrayal of the foreground and emphasize the illusion of recession.

In *Delphiniums and iris* I enjoyed myself with wet-on-wet washes. The resultant watermarking created a lively background effect that suited my approach to the subject. Because I didn't want the plants to merge with the background I left a thin line of white paper around the edges, especially where the hues of the subject were similar to the background, effectively producing a white outline. To control the paint I used a less dilute mix (which included some gum arabic) as I worked around the plants, but gradually added more water as I 'pulled' the wash away into the wider background space. While the wash was wet, I dropped in more paint, varying the colour mix as I went and allowing it to flow as it wished.

▲ *THE BARFF*
Watercolour, 20½x11¾in (53x30cm)

▼ *DELPHINIUMS AND IRIS,*
(detail)
Watercolour

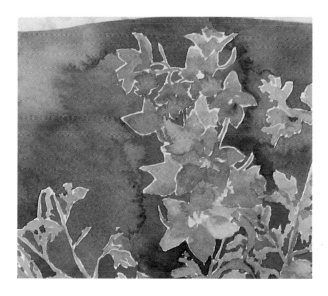

Because the white line was dry paper and the adjacent paint more viscous, there was no risk of these wetter washes flowing over the flowers. Remember that adding gum arabic increases the solubility of the dry paint layer. This meant that I could not build up the tone of the background by applying further washes so I had to make a decision to paint the final tone in one wash.

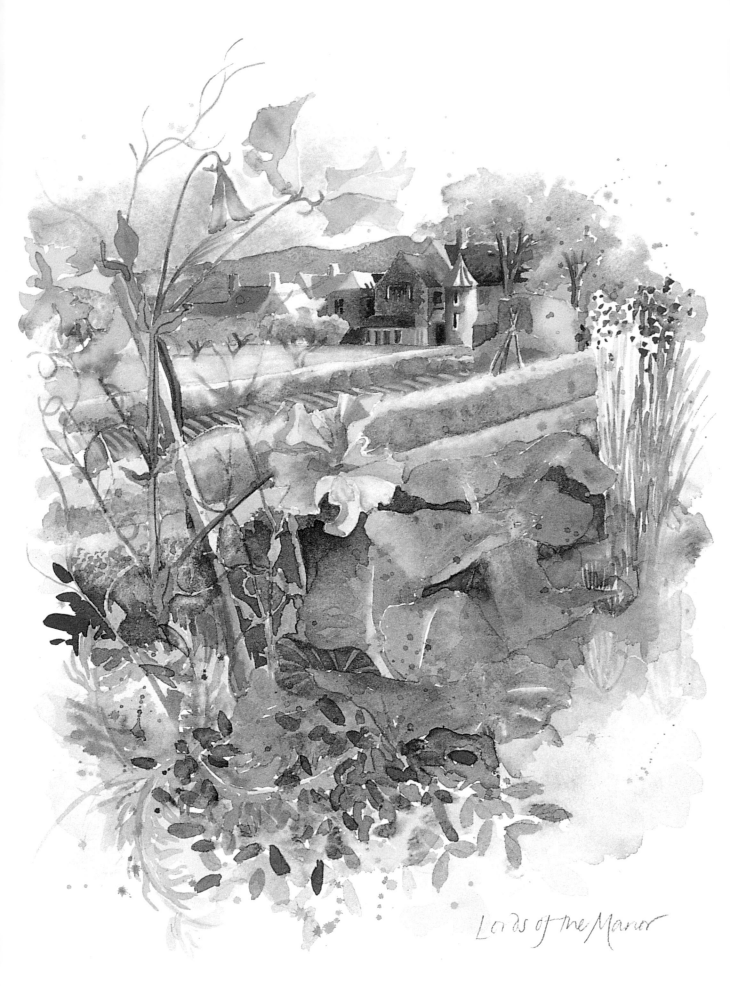

Lords of the Manor

SPATTERING

I sometimes use spattering to give a sense of looseness to a piece. In *Lords of the Manor* I was trying to capture the feeling of floating grains of pollen and the insects that abound in a garden in high summer. The technique is very simple: load a brush with paint and flick it confidently over the area you wish the colour to land on. If this is a particular area you can mask out the rest of the painting with sheets of paper. Some artists use a toothbrush dipped in paint – running a knife sharply along the top of this produces finer, more even spattering. Practise to see which texture suits your work. The random effect produced is a very good way to enliven a large area of flat wash, and you can introduce as many hues as you like with less chance of overwhelming the base colour. It's a good way to create optical mixing in watercolours.

PAINTING FLOWERS IN WATERCOLOUR

Watercolour seems to be the natural medium for the portraiture of flowers. Its translucency mirrors the effect of light shining through petals and its potential for soft colour and tone allows you to reflect the hues of nature. There is more than one way to approach flower painting. You can, for example, work

out of doors, *en plein air*, including the background while concentrating on individual flowers. Alternatively, you can set up still lifes in the studio, once again with or without backgrounds. In a completely different vein you might choose simply to draw inspiration from your subject and portray the colour and form so as to create a patterned effect.

FLOWERS IN CLOSE UP

These first examples were so individually arresting that I chose to focus in on them and ignore the backgrounds. The markings on these *Fantasy tulips* looked almost unreal, in fact they looked as if they had been painted on with watercolour. Even though the painting is small scale, I used a wet-on-wet technique to show how the colour was softly diffused along the capillaries of the petals. There was so much detail in the flowers themselves that I felt a background would be distracting.

◀ *LORDS OF THE MANOR*
Watercolour, 13¼x11¾in (34x30cm)

▶ *FANTASY TULIPS*
Watercolour, 14½x12½in (37x32cm)

All these roses in Rosa mundi, *fairy roses and 'Silver Jubilee' rose* were painted on Fabriano rough 140lb (300 gsm) paper, with a No.14 brush without any pre-drawing at all. Try it – it is an extremely liberating experience! The paint on the *Rosa mundi* was applied in quite intense washes, building up the shadows by overpainting layers of exactly the same wash, although I used a little violet-ultramarine wash in a few areas to liven things up and contrast with the yellow stamens. Some of the leaves were painted with wet-on-wet washes. Although I have given a hint of the way the light was hitting the flowers by varying the tones and hues, I was most interested in the pattern and balance of the painting on the white page.

The fairy rose was painted with a strong pink wash, but the colour was constantly controlled by removing some of the paint with a second damp brush. The background leaves are painted simply as a darker tone, and this in effect turns the white paper into the lightest value on the flowers.

Tissue was used to blot areas of the 'Silver Jubilee' rose, leaving just the right dampness of paper to overpaint once more. When the washes were completely dry I used the very tip of the brush and a stronger mix of paint to add in the fine veins, using these to help describe the contours of the petals.

Watercolour is a good medium for painting on location because of its portability, and all these examples were painted outdoors in front of the flowers. The wild *Corsican cistus* and the very domestic *Irises in the walled garden* (pages 94–5) were both painted from life. Both have

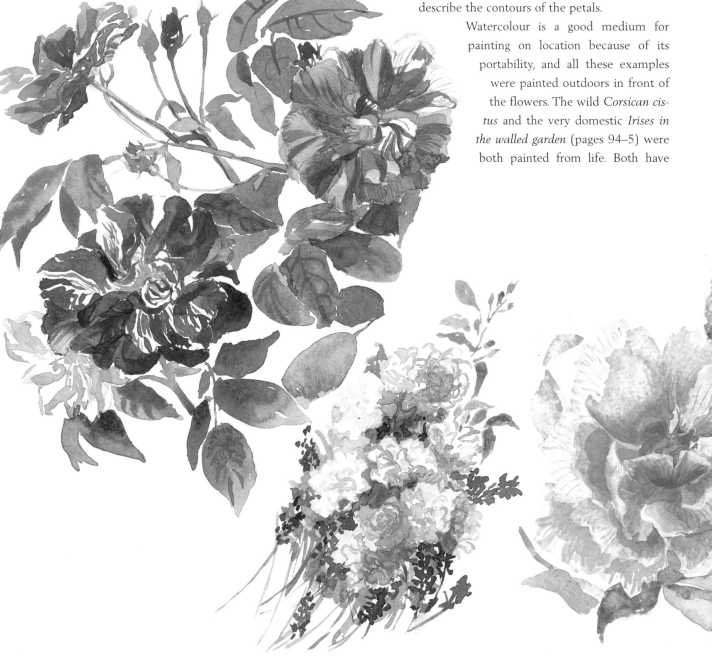

quite interesting formats. The long, low iris painting seemed to reflect the quality of the peaceful garden, whilst the towering little painting of cistus underlined its humble placing against the majestic mountain backdrop. The latter was almost finished on the spot – I think I simply darkened and warmed some of the foreground tones later so as to increase the focus on the flowers. The irises were completed in the garden, and the background added later with the help of photographs (inclement weather having stopped me from working). I think the background lacks the freshness of the flowers because I had as much time as I wanted – too long – to consider and rework it.

In all of these paintings the flowers are observed with a degree of botanical detail because they are the main focus of the works. However, I will often faithfully record only a small part of the plant and then repeat this more freely across the whole – as in the painting of the cistus. Unless your intention is just to do a focused, botanical study, don't feel you must record every leaf and stamen literally; the time involved may rob the work of freshness and enjoyment.

◄ ROSA MUNDI,
FAIRY ROSES AND
'SILVER JUBILEE' ROSE
Watercolour, 13¼x18¼in
(34x47cm)

► CORSICAN CISTUS
Watercolour in sketchbook,
16¼x5¾in (42x15cm)

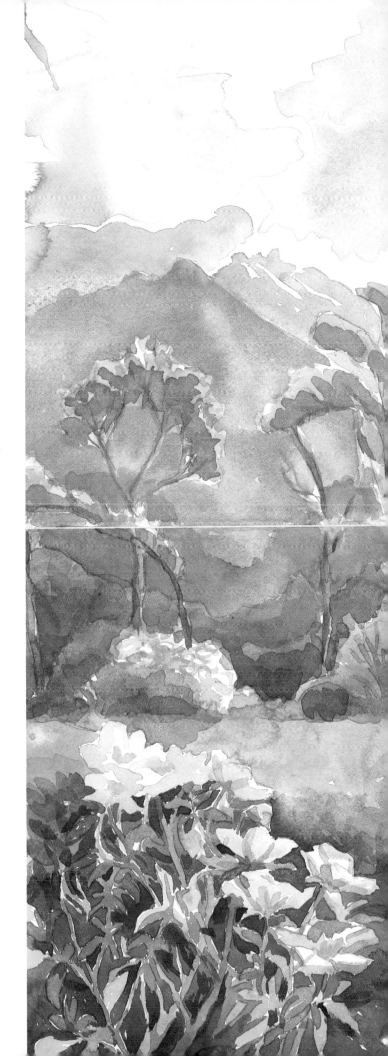

THE IMPRESSION OF PLANTS

When painting a whole garden full of flowers you rarely have time to paint every detail of every plant, even if you should wish to. So how do you convey the impression of varied planting? The marvellous walled garden in Scotland depicted in *Herbaceous borders, Langwell* (page 77) was entered through a secret portal buried amongst dark pines. When the door was flung open my eyes, accustomed to the gloom, were greeted by a rosy haze of blooms so light it seemed they would float away and only remaining because tethered by the structure of the walls and trees around them. Some of the plants had strong characteristics – round heads, spiky foliage – and I highlighted these features, but in general I painted the blooms as colour blobs or areas of colour. The further away they were the more they became simple masses, observed as patches of light and dark. Notice, too, that the interval between these tones is less than in the foreground planting and the background has less textural detail to suggest a sense of recession and space.

By highlighting the detail of plants with strong characteristics you can give your painting authenticity. For instance, in the detail from *The Dovecote border* (pages 12–13) the kniphofia (red hot poker), rose and nepeta (catmint) are recognizable but the general planting to the left is rendered as a mass of colour and tone.

THE DOVECOTE BORDER (detail)
Watercolour

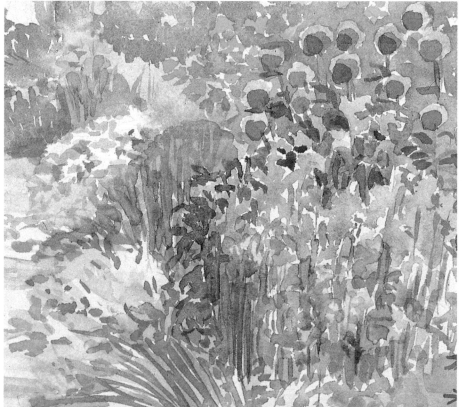

▲ *IRISES IN THE*
WALLED GARDEN
Watercolour, 11¼x25¼in
(29x66cm)

◄ *HERBACEOUS*
BORDERS, LANGWELL
(detail)
Watercolour

PAINTING WHITE FLOWERS

I am often asked, 'How do you paint white flowers?'. It helps to have a painted background for white blooms so that you are able to use the white paper for the strongest highlights. Different intensities of grey are then used to describe the shadows and subtle tones. Grey does not have to be colourless. As you have seen (page 64), mixing complementary colours together can produce very lively greys. Avoid adding black because it deadens hues. My favourite 'botanical grey' is a mix of ultramarine and

VIBURNUM, PHILADELPHUS AND LILAC
Watercolour, 14½x21in (37x54cm)

light red, which is a red-blue combined with a 'greyed' red-orange. In different proportions the mix can go from warm to cool in temperature; its neutral stage is a subtle 'greyed' violet. I used it extensively in *Viburnum, philadelphus and lilac*, an arrangement on my kitchen table. I also introduced green and cerulean washes to mingle with a wet application of this mix and, sometimes, where the light was warmer, added a mix of naples and cadmium yellow. This shows up well in the heads of the *Viburnum opulus* to the far left. So in the end, although the effect is of white flowers, there are few truly white areas of paper – and most of those are reserved to represent the light coming through the kitchen door.

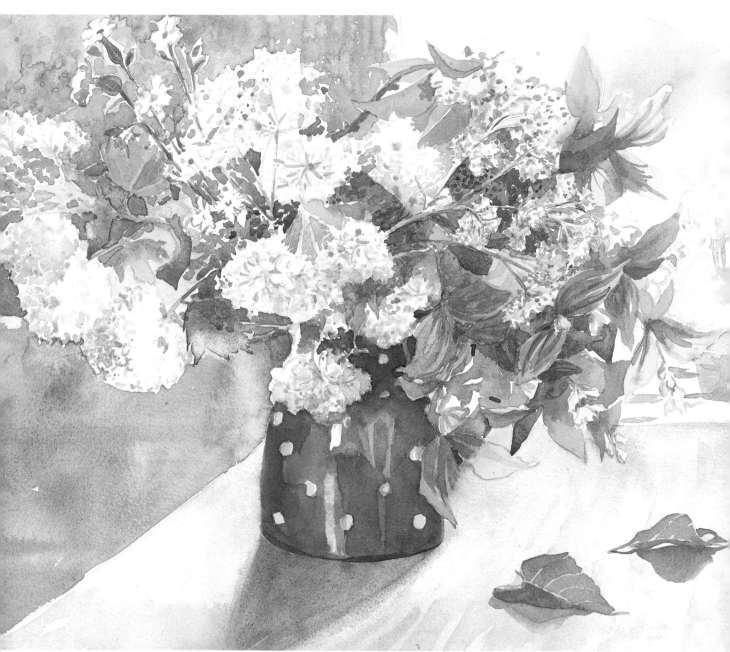

demonstration
TRIPLE FLOWERS

Having stretched a piece of my favourite 140lb (300gsm) Winsor & Newton paper the night before, I had to decide if I would paint this entire riot of bold coloured flowers or just choose some. The anemones had the potential to become a strongly patterned painting. A quick sketch looking down on them, set against a dark ground, confirmed my feeling that I could produce an interesting concentric composition – but my heart was not in it. I was seduced by the orange

lilies and curvy tulips. By sitting on the floor I put my subjects 'on a pedestal'. From this viewpoint the lilies did not stand too tall against the foreground flowers, so that the composition fitted onto a landscape format. I lit the still-life from a low angle that backlit the tulips, gave slightly darker margins to the composition and highlighted the middle of the painting.

I began with a rough confirmatory sketch (right) which took ten minutes and, trying not to lose too much of that spontaneity, went on to a considered pencil drawing which probably took an hour. I selected my brushes, a No.14 and a No.7, and organized my palette, one colour to each compartment in related groups: thus I had Payne's gray, cobalt turquoise, ultramarine, cobalt blue, Winsor violet 728; then cadmium red, permanent rose, light red; and olive green, yellow ochre, cadmium yellow and Winsor yellow. The yellows were given two compartments each in the palette because I use them extensively to mix greens and they get very dirtied as I dip my brush in and out. The second portion of clean yellow is then available for painting pure colour and clear highlights.

I always begin painting the flowers first, partly because I enjoy them but also because they move, and fade at an alarming rate, especially indoors. As stage one, I began to work at the point of greatest contrast using bright saturated colours where the lighting was strong, and gradually greying hues as they receded from the light. My first applications of paint were quite wet and I mingled the different tones in mixed colour washes. In most places the next layer of paint was applied over this base when it was dry, producing crisper edges. I occasionally used a No. 7 brush for detail. My greens were made from different mixtures of olive green, the two yellows, ultramarine, cobalt blue and Winsor violet. The halo of light around the backlit anemone stalks was painted first, a soft wet wash of Winsor yellow with the tiniest touch of olive green. Winsor violet mixed with olive green produced the darker colour on the anemone stalks: with the addition of cobalt, this mix made a good grey-green for the tulip leaves on the far left.

Orange was mixed from cadmium yellow, cadmium red and permanent rose. The latter two were mixed together to give the base reds of the tulips and, with the addition of Winsor violet 728, the pink of the anemones. All these colours were laid down in strong saturated washes, built up tonally by further layers of strong colours. The last washes were mixed with gum arabic to produce a luminosity and sparkle. The nearer the light source they were, the purer their colour. Under the same light, the *local* colour of the violet anemone is darker

than the orange lily. Lighting changes these values: the *atmospheric* colour of the anemone in the centre is now much lighter than the lily to the far left. Having worked solidly for about two and a half hours to complete the flowers, I left the painting until the next day.

The next stage was to paint the 'jugs'. For the teapot I used a mix of a little cobalt blue, Winsor violet 728, light red, cadmium yellow and yellow ochre. I painted over the whole shape with a pale but warm base wash of cadmium yellow. For the reflected light from the tulip on the handle I added hints of green and pink to the yellow ochre; this was the first time I had used yellow ochre in the painting. Also making its debut on the background

jug was cobalt turquoise. The jug holding the anemones was painted wetly with quite strong mixes of pigment as it appeared dark in tone against the background light.

The last stage was the background. I liked the horizontal strips at the bottom of the composition. The pale strip highlighted the feeling of light in the centre of the painting and I felt the dark base gave weight and 'grounded' the composition. I didn't want the light band (mainly cadmium yellow and yellow ochre) and the blue background to have hard adjoining edges, so in the lightest centre-point of the composition I allowed the edges to bleed together: elsewhere they were loosely painted over each other.

◀ *STAGE ONE*
I began painting with bright hues where the light was strongest.

▼ *STAGE TWO*
The flowers were completed first as they would have changed considerably by the next day.

▶ *TRIPLE FLOWERS*
Watercolour, 18¼x26½in (47x68cm)

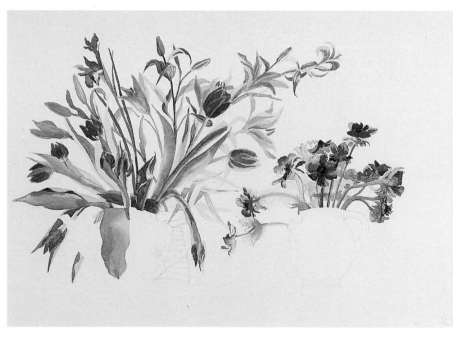

I chose blue for the background because it is a colour that gives a sense of space, as well as evoking peace and calm. In this case it was also the complementary of the orange lilies. The base wash was made up of cobalt turquoise, cobalt blue and Winsor violet 728, veering towards a greener blue nearer to the lilies, and more towards violet next to the anemones. After applying one wash carefully around all the plant shapes I darkened the areas closer to the centre of the plants with a second wash, not necessarily using the same colour mix. I didn't want to lose all the white paper, so I faded out the washes as the flowers thinned out at the top of the composition, accomplishing this by using a broken wash and by blotting any excess paint with tissue.

To the right of the composition was a large area of background. I didn't want this to have a flat wash as it might have made the tones across the painting too similar, so I used a broken wash, applying paint in criss-crossed short strokes with my large brush. This let the white paper shine through in places. To apply paint even more softly, in the far right-hand corner I used a tissue soaked in green-blue and dabbed pigment onto the paper. Finally, I looked again at the tonal values across the painting and darkened the tulip leaves on the left further to enhance the feeling of light in the middle and right of the painting.

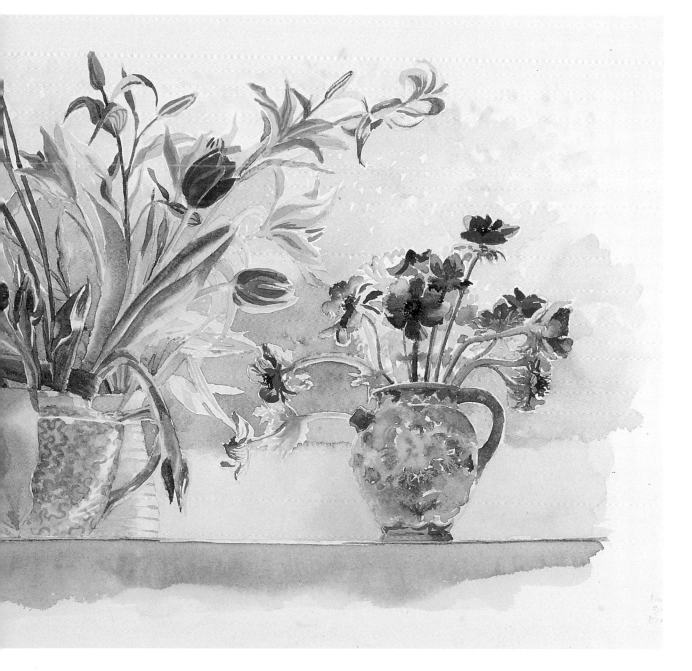

chapter eight
PASTEL

EXERCISES IN COLOUR AND TONE

Chapter 7 on watercolour started with an exercise in colour and tonal values – trying out the various exercises and techniques on pages 102–9 seems a good way to approach pastels. When you pick up a pastel you have a ready-made stick of pigment of a particular colour and tone. The mixing potential of these sticks is more limited than paint, so you need to be able to recognize their individual colour and tone in order to apply them directly and accurately.

BLENDING

Mixing colours together by *blending* means putting down a pastel mark and then carefully smoothing it into the paper and/or another colour, by hand or with an instrument such as a torchon. My favourite blending tool is the finger because it really pushes the pastel dust into the interstices of the paper. Blending with a torchon, cotton bud or brush gives a soft effect but also removes quite a lot of pastel pigment from the paper – this is very upsetting for a mean conservationist such as myself who mentally calculates the cost of pastel dust!

I used blending for the background trees, vegetation and buildings in the painting *Willows*. The technique creates a soft effect which gives a feeling of things not quite being in focus and thus further away. You've probably come across the painting lore that says that light tones recede in the picture space and darker tones

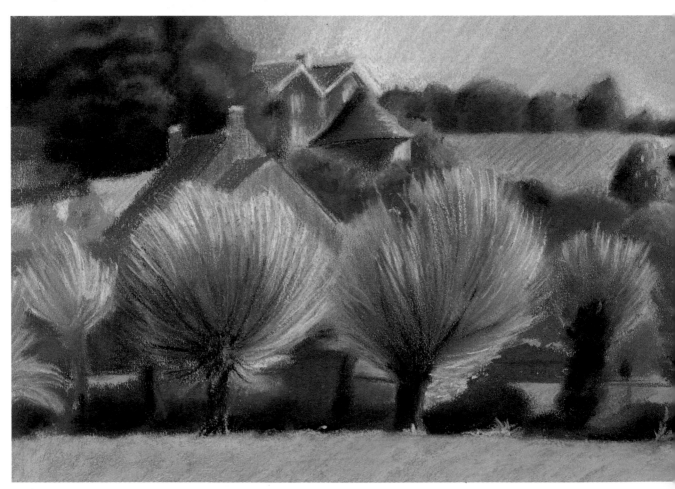

advance, but I was able to use dark tones for the distant horse chestnuts and still make them recede by using this fuzzy approach. With one pastel, try to apply colour to paper in thinner and thinner layers, smoothing it out with your finger to lighten its tonal value. This is the pastellist's equivalent of a graduated watercolour wash. In the same fashion blend in another colour: by using different proportions of each colour you produce different end results. In fact, the order in which you lay down the colours can also affect the resulting hue.

Just for interest, try using more than two colours to see what the effect is. I suspect the end result will look very muddy and that after a while the paper will become *saturated* – this means that the paper cannot physically hold any more of the pigment, so the colour literally begins to drop off it. This problem of saturation taxes even experienced pastellists. One remedy is to spray with fixative between layers, and another solution is to mix your own ground with gesso and pumice powder and apply this to renew the key or tooth (this is really only possible on boards).

In order to get to know the hues and values in your selection it is a good idea to create a *tone scale* and match your pastels against it. Choose a mid-toned piece of paper for this exercise to show up the lights and darks equally well. You will also need black and white pastels, a torchon or cotton bud, a stiff brush and a plastic eraser.

Blend black pastel and white pastel together on the paper to make a series of grey squares, probably about six, varying in intensity from a pure white square at one end to a pure black one at the other (just doing this teaches you a lot about creating tones). Leave lots of

TONE SCALE

WILLOWS
Pastel, 9¼x23in (24x59cm)

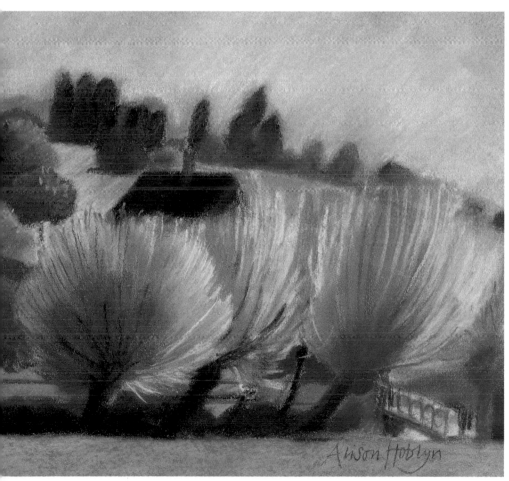

space between each square. Now pick out your coloured pastels and try to judge where they belong along this scale. As with watercolour, it is easier to decide on their tone if you squint at the patches of colour. Don't worry if you put a colour in the 'wrong' place; just try to modify it with another pastel to make it fit the scale. You will doubtless find that some of your colours hover between one tone square and another which is why I suggested that you leave space between them. You may find that several of your colours are clustered around one of the tonal values: this makes it much clearer where you need to augment your palette or when you might need to modify the values of some colours.

SHADING

You can also produce areas of graduated tone by carefully overlapping pastel strokes of different values, to make them merge. This is done by the technique of *shading*. If you have ever used a coloured crayon you will remember the way you needed to control your pencil strokes so that the colour became an even mass on the paper. This was often done by drawing the lines in one direction, merging them into each other and working gradually across the paper. It is just the same technique with pastels but perhaps a little simpler, as soft pastels are much easier to merge than crayon. Shading is a particularly useful way to model a three-dimensional form such as a tree-trunk or pot. When gradually shading in values from light to dark, care is needed at the transition point between one tone and another. You don't want to draw the eye with a sudden jump in tone between one block of colour and another. Nor do you want your attention caught by a transition that has been overworked by too much overlapping of pastel strokes as its texture will be very different to the surrounding areas. It's worthwhile practising shading as it is an important technique in your armoury.

In *The Granary window*, a painting of a garden seen through an interesting window, I have used shading to show the forms of the pears and jug and their crisp silhouettes. The curtains were shaded and blended to evoke their velvety softness. Sometimes the lines of definition between these techniques become as blurred as the pastel!

Shading is the technique I use most for closely observed paintings of flowers because it gives the clean, gradated tone needed for modelling complex forms. Look at the example of the tulips in *Tulips on a striped cloth* (page 104), especially the vertical petal on the overblown flower: this is shaded in about four tones that gradually merge together.

The linear character of pastel strokes is more obvious when *shading* than it is when you are *blending*: the next techniques of *hatching* and *feathering* will exploit this characteristic further.

HATCHING

The term *hatching* describes the laying down of roughly parallel strokes of pastel colour. This can be done in a formal or informal fashion, in a variety of directions, using one or many colours. With this technique, changes in tone can be achieved by using different thicknesses of line or by varying the space between the lines. These linear marks need not be straight – hatching can be used very effectively to accentuate the curved contour of an object. The careful use of lines will impart a strong character to your work, emphasizing its quality as a drawing. Care needs to be taken when working over hatched areas as they need to be kept clean and crisp.

I used hatching extensively for the background to the flowers in *Tulips on a striped cloth*. I used it in a random way to contrast with the carefully modelled tulips. By introducing quick strokes of bright salmon pink to the bottom right of the picture I tried to convey light reflected from the pink flowers, and also to integrate the subject with its background through hue.

FEATHERING

This technique is very like hatching but the linear strokes are laid more lightly and quickly with the end of the pastel, usually over existing colour. The best use of this technique is as a modifier. You can use it to restore texture to a particularly flat area, to lighten or darken values by overlaying the appropriate tones, or to cool down or warm up colours by feathering in new hues. It is useful when the jumps in tone or colour between separate areas are too great, and you want to pull them together – the lightly applied lines can unify without obliterating. Furthermore, you can use this technique to transform an area into a mélange of rich colour, and also to enhance and clarify forms.

THE GRANARY WINDOW
Pastel, 23x17in (59x44cm)

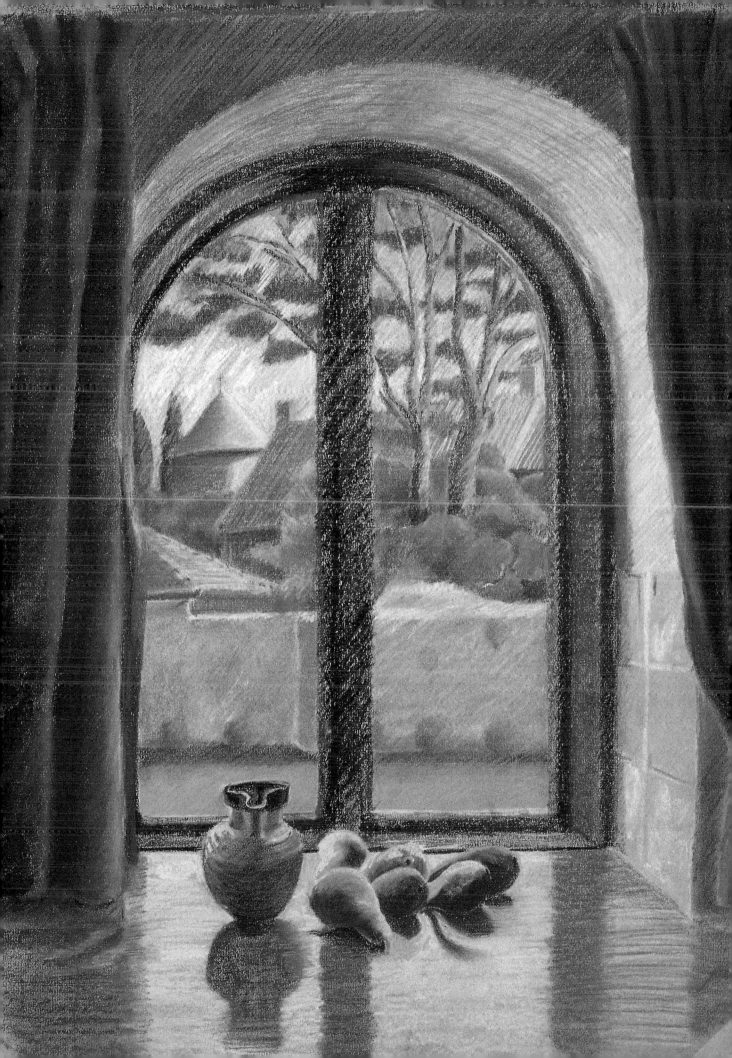

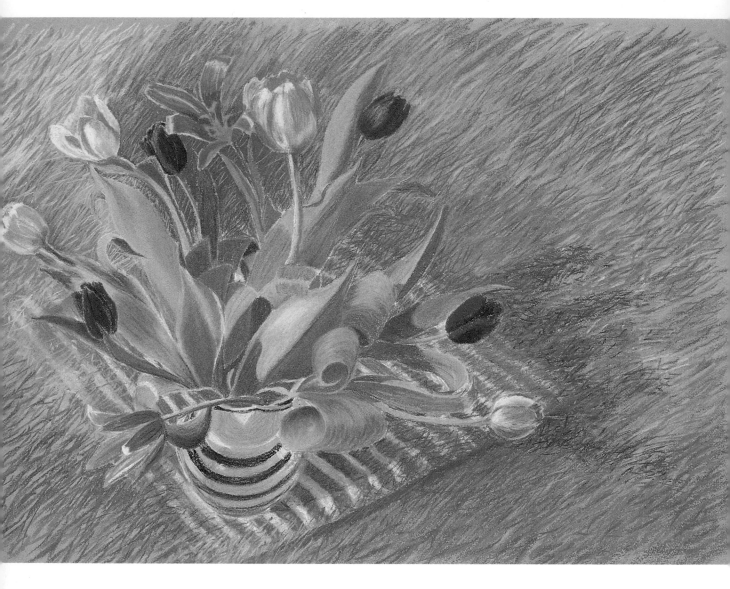

COLOUR AND FORM

Light and dark tones help create a three-dimensional appearance, but an awareness of the effects of colour can add another dimension to the modelling of objects. The Impressionists, particularly Auguste Renoir (1841–1919), embraced the theory that warm colours advance and cool colours recede; that light was expressed with oranges and yellows, and darkness was represented by blues and violets. And as you now know, these are complementary pairs of colours.

Find a simple three-dimensional object – I chose a flowerpot (opposite) – and try to bring it solidly to life on the two-dimensional paper. The range of colours I used are shown next to the painting. I suggest you use hatching and feathering techniques as these will exploit the colour. If you use blending the effects will be less vibrant, even dull. Set out to persuade a viewer that the

▲ *TULIPS ON A STRIPED CLOTH*
Pastel, 20½x28½in (53x73cm)

pot is curving away from the light by using more cool, receding hues in those areas, and use warm advancing colours where the light strikes it. The proportions of each colour you use will alter as the light gently begins to fade away into the darkness.

My painting was done on a warm, buff-coloured Canson paper. Although I generally prefer the reverse side, this time I used the 'right' side of the sheet as the rougher texture 'broke up' the lines of hatching to make them look less mechanical and allowed the paper colour to work as a positive part of the piece. I used hatching and feathering predominantly: the hatching was sometimes not applied diagonally, but along the contours of the flowerpot to emphasize its shape.

◀ *FLOWERPOT STUDY*
Pastel, 7¾x7¾in
(20x20cm)

▼ *FIELD STUDY*
Pastel, 6½x7¾in
(17x20cm)

OPTICAL MIXING

In this technique you do not mix the colours together physically, but their proximity modifies the appearance of each one. This is *optical mixing*, a technique which exploits the fact that the eye perceives a new hue or tone created out of adjacent areas of pigment. Optical mixing can be useful to liven up or calm down an area of one colour that might be too dull or too garish when applied in 'undiluted' pastel. Edgar Degas (1834–1917) was a great proponent of using small dabs of complementary colours to modify the hues of pure pastel.

The examples on this page show how optical mixing of colours can work in practice. The more brilliant a colour the greater impact it will have and so it is more likely to 'advance' in the picture space. In *Field study* a green field is made to recede into the distance by being 'greyed'; this is done by overlaying the green with some of its complementary – red.

The feeling of shadow under the tree in *Aegean study* is not conveyed by using blacks and greys but by using dark-toned blue and violet and enlivening them with their complementaries – orange and yellow. Using these colours makes one feel the sun is very much the light source here. The pastel was applied layer over layer – white pastel being one of the layers to give a brightness not available from the mid-toned support I used. Fixative was applied between layers to provide enough key for the next one to be able to stick; without it the paper would become saturated and the pastel would flake off. The resultant very thick pastel surface is not unlike the impasto technique in oil painting.

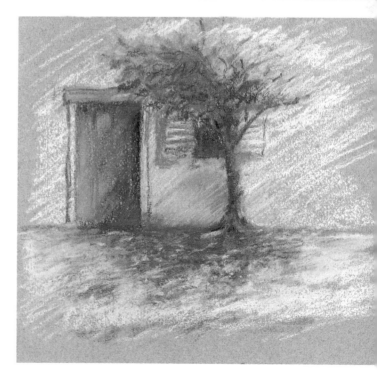

▲ *AEGEAN STUDY*
Pastel, 6½x5in (17x13cm)

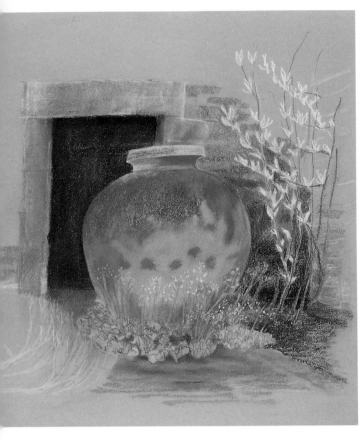

▲ *TUSCAN POT*
Pastel, 15½x15in (40x38cm)
Pastel is a marvellous medium for evoking the surface texture
of an antique garden pot.

▼ *ANEMONES*
(detail)
Pastel
Warm and cool yellow and pale pink are scumbled over
viridian green for the lighter areas. I used warm yellow and
violet over a dark green-blue for the shadows.

SCUMBLING

A lovely way to mix colours optically is *scumbling*. This technique is derived from oil painting where colours are applied over each other lightly and with a scrubbing motion of the brush, allowing the colours underneath to show through the top layer. My style is to apply colour over colour with light circular movements. Each successive layer allows some of the hues beneath to shine through the airy holes produced by the scribbles. Because the pigment is laid down so lightly the paper can glow with colour but is not in danger of becoming physically saturated. The result is both complex, and free and easy. It's a great way to regain the relaxed approach you might have lost when attending to a very detailed part of the painting. The areas where it is used can be built up to an astonishing degree of texture, or display a lot of plain paper below. Like *feathering*, you can layer on countless colours to produce really rich effects, but scumbling has a 'wilder' feeling. It evokes a different mood (and creates a different texture) to the

SCUMBLING

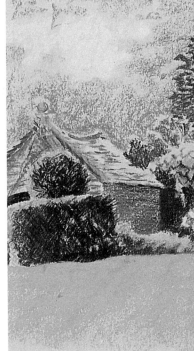

more controlled feathered strokes. Experiment with this technique, working light over dark, and then vice versa. Try superimposing complementaries and harmonious shades. I will use it to describe the texture of a surface as on the garden pot in *Tuscan pot* with its wonderful patina, or to vary the interest between foreground and background as in the painting *Anemones* (pages 8–9).

STIPPLING

Stippling uses a system of dots and dashes to build up form and shape. Like hatching and scumbling it can also be used to enliven or tone down large colour masses. The size of dot you use depends on the type of pastel but obviously it can never be very large in scale – to develop a whole painting in this technique could be very time-consuming. You will be surprised how effectively a few small dots of colour can modify a large colour area. If you feel one block of colour is overwhelming your painting try stippling it with a hue taken from another part of the work. The stippled colour will act as a visual link and

may be just enough to unify the piece.'

I used controlled stippling in *Walled garden, midday* to give a very precise rendering which somehow suited the orderliness of the place. In the painting *Topiary bird* (pages 70–1), the technique matched the image I had in my mind. The light was from a warm autumnal sun and it made the close-textured topiary glitter and return a stunning mix of colour to the eye. Although this was a very strong impression at the time of painting, the photographs I had developed later did not convey the scene at all – that is why one paints.

The above has, I hope, neatly parcelled up the different strokes. No doubt you will end up ignoring half of them, but when you do decide which pastels suit you best, you will make marks as individual as your handwriting. Techniques are your slave and not your master. So don't worry if you can't work out whether to label the last strokes shading or hatching; I do a fair bit of 'shatching' and 'blading' without much anxiety.

STIPPLING

▼ *WALLED GARDEN, MIDDAY*
Pastel, 9¼x22½in (24x58cm)
Stippling is used mainly for the background trees.

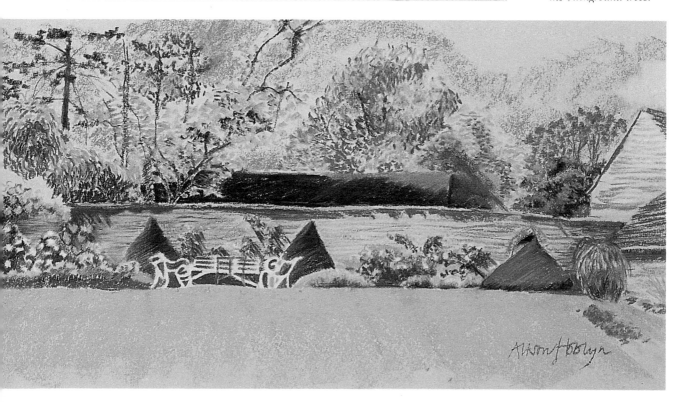

EDGES

A common fault in beginners' work is to make all the edges of a painted object highly defined, so that it stands against the background like a flat cardboard cut-out. Depending on how the light is striking an object, some edges fade into the background, whilst others are very clear cut. Many artists use the pleasingly whimsical description, 'lost and found' edges. A 'lost' edge almost merges with an adjacent area because the tones and/or colours are so close. A 'found' edge stands out strongly because its tones and/or colours contrast strongly with the surroundings. This is true whatever medium you use. Observing this correctly will immediately help you to create an authentic three-dimensional object on the two-dimensional paper surface.

Some subjects such as buildings have inherently crisp, defined edges. Others such as trees and bushes have more amorphous shapes. Having said that, you may want to manipulate reality, and edge quality can contribute towards the mood of the painting. For instance, although in reality the tower behind the geraniums in *Flowers after rain, Corsica* had crisp, classical lines, I gave it soft edges because I wanted it to be just a hovering background presence. It was also very close in tone to the sky from which rain had just fallen, so at times its edges melted into the clouds.

The topiary garden, dusk (pages 118–19) appealed as a subject because it was a marvellous example of nature tamed and formalized. It suited a hard-edged rendering, whilst the distant trees were softer because they were

▶ *SNOWY GARDEN*
Pastel, 15½x15½in
(40x40cm)

◀ *FLOWERS AFTER*
RAIN, CORSICA
Pastel, 21½x16¼in
(55x42cm)
Again, pastel is marvellous
for these terracotta pots.

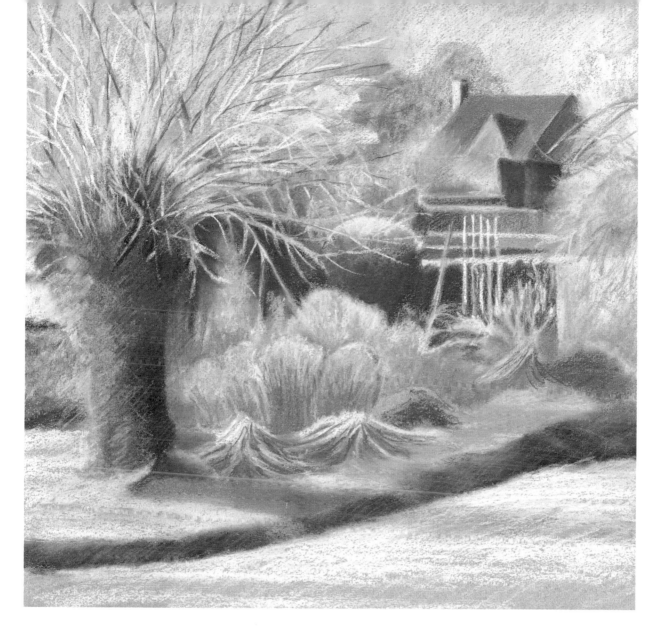

both more 'natural' and also further away and out of focus. I sometimes use this technique of a softer edge treatment for anything that is not in my immediate focus, so the back blooms in a vase of flowers might be fuzzy-edged and fade into the background.

The way you put your vision of a scene on paper is going to be unique. You can see that apart from rendering literally what I saw in front of me I had also formed an idea of what I wanted to express. I use techniques to make things appear as authentic as possible, but also to manipulate or heighten reality in order to express myself more clearly.

HIGHLIGHTS AND WHITES

At the end of your pastel painting comes a very satisfying moment when you can add or enhance the highlights – the lightest areas that give sparkle to the work. Unless you are using white gouache (which seems like cheating to me) this is not an option available in watercolour. You

may need to sharpen up the highlights for two reasons. While overworking the painting the colours may become subdued with dust from your hand or other colours, or fixative may have darkened all the tones. Simply re-work the area, using fixative to provide a key if necessary, but remember that you don't always just use white. The lightest tone is dependent on the tonal key of your painting: thus if you are depicting pale pink roses your highlights could be pure white; and in a sombre woodland scene with dark greys and browns, it may be a mid-value orange.

White is a strong contrast on a mid-toned paper and should be used like a treat. You would imagine it would be ideal for a snow scene, but like the watercolour on page 37, the picture *Snowy garden* has few areas of true white. In fact even the 'whitest' foreground area of snow is overhatched with a pale green tint. Delicate yellow strokes are used to represent weak sunshine, whilst the shadows are blue/violet and very cool.

WISTERIA WALK

In *Wisteria walk* I used a variety of techniques. For the amazing (metre-long!) racemes of this wisteria I used *stippling*, because hues can be built very subtly in this way. Although the overall colour effect of these flowers is violet, close inspection reveals dabs of pinks, greys, greens, yellows and white. The colours mix optically, giving a more lively end result.

The underneath of the loggia has been built up with diagonal *hatching*. It is a sombre-coloured area which

gives the effect of deep shadow. The tiny bit of light reflected is suggested by allowing some of the paper to show through. Try hatching bright or complementary colours one over another – you will find these create very stimulating effects.

Blending has been used on the wall to give a soft and subtle gradation of colour and tone. Here it looks as though the paper will not hold any more pastel powder. The effect is very different to that of the grass with its strong directional strokes and revealed support.

The frothy yellow plant below the pot was ideally

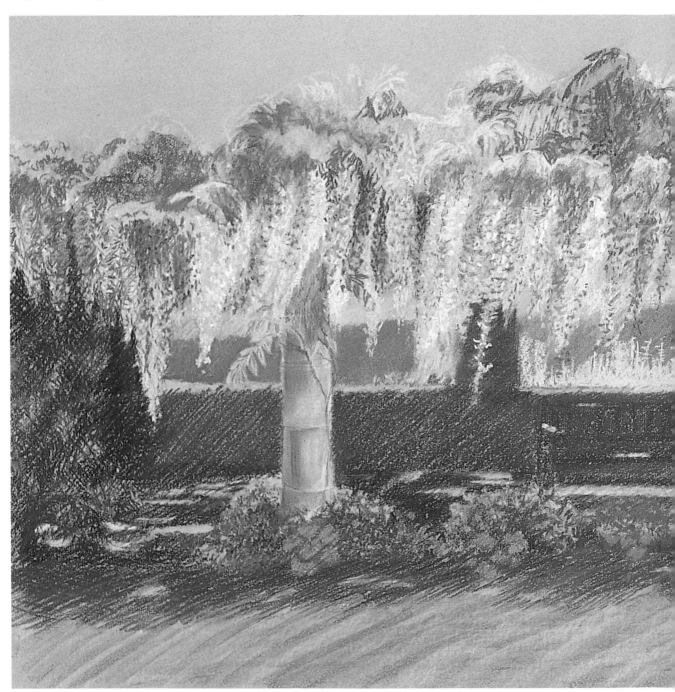

represented by *scumbling*, using the pastel loosely in a circular movement, one colour over another. The background colour shows through as a darker tone.

Having used many different textures within the main area of interest, I wanted the sky to be flat. I created an even effect by using a *dry wash*. For this I used the side of a pale blue pastel to lay down several wide strokes, then rubbed the powder over the sky area with a tissue. The broken bits of pastel in the bottom of your box can be powdered up, sprinkled on the paper and rubbed on in this way too. You can also make interesting variegated washes.

WISTERIA WALK
Pastel, 21x41¼in (54x106cm)
This large painting uses several pastel techniques. I wanted to capture the flowers moving in the breeze.

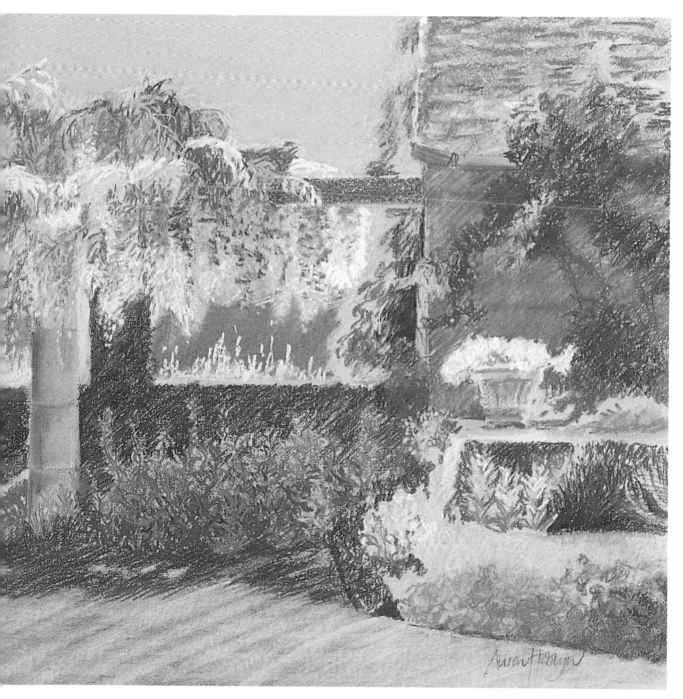

SUPPORTS

The dry wash just mentioned can be laid over white paper to produce any colour support you wish. However, as it takes up some of the valuable 'space' left for subsequent pastel layers, a better alternative when beginning is to choose from the enormous range of coloured papers. For the painting *The glasshouse in April* I used a warm ochre board, fairly light in tone compared to my favourite *gris clair* Canson. I wanted to leave quite

a lot of background showing through to give an idea of the airiness and light in the conservatory. If the ground had been white it would have been too chilly.

THE GLASSHOUSE IN APRIL
Pastel, 24x18¾in (62x48cm)
In this painting I wanted to convey pattern as well as light, so I chose a crisp drawing style and a simple composition.

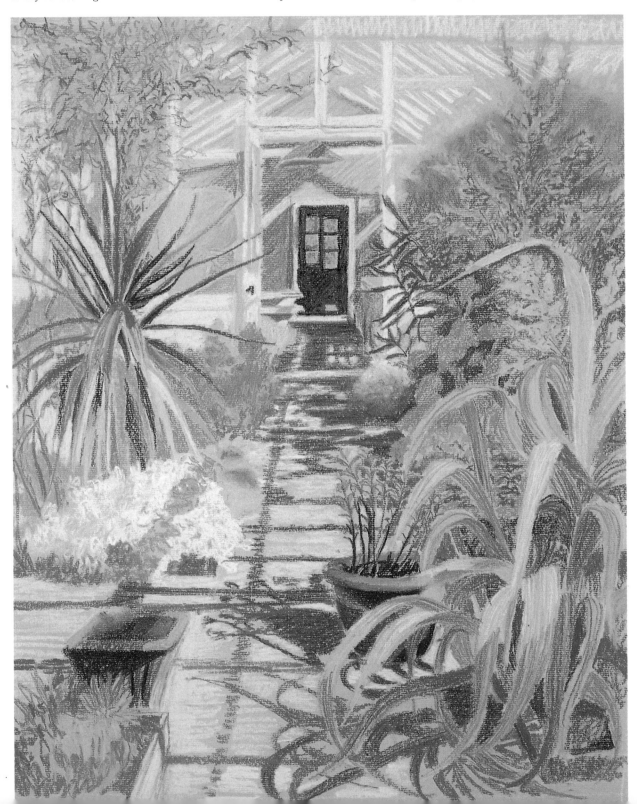

demonstration
HYACINTHS

This subject fascinated me because I wanted to reproduce the heaviness of the drooping flowers. First I made some quick sketches to compose the plant – I needed to make sure the flowers balanced. My viewpoint turned out to be quite straightforward, but I lit the flowers strongly with a desk lamp from a low angle. I ignored all the 'mess' in the background as I decided my treatment of this would be homogeneous and reinforce the idea of the light source. The room in which I was working was warm, and dense with the flowers' scent, a combination which contributed to a decided somnolence. Having completed the outline drawing (page 55), I decided to warm up my palette to reflect this mood.

The colours I chose for this painting are shown below – it should be easy to find a similar selection amongst any manufacturer's range. Mine were a mix of Unison, Conté and Rowney. In an ideal world I would list exact references but any self-respecting artist's collection of pastels would be like mine, in pieces, used to the very stub and unlabelled. I reproduce the individual colours to show how a limited number of hues and tones can be a good starting point, and that they can be mixed to a degree. To begin with, colours are best chosen with the subject already in mind.

◀ PREPARATORY
SKETCHES
Pencil
These two little sketches
have been reproduced here
at their actual size.

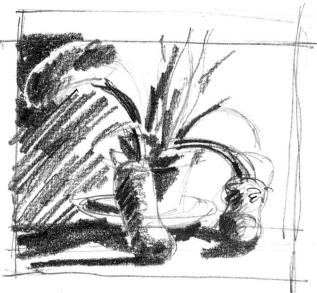

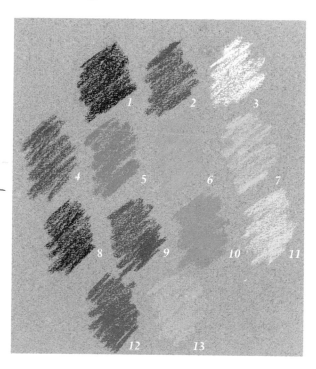

▲ THE PALETTE FOR 'HYACINTHS'
I used only 13 colours – quite a small range for pastel painting. Using watercolour I could have refined my choice to about 5 mixable colours. The colours needed in the background were 1, 3, 4, 8, 9, 11 and 12.

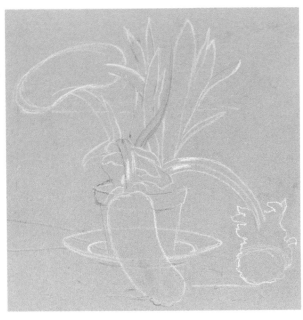

◀ STAGE ONE
*Outline drawing for
Hyacinths.*

▼ STAGE TWO
*Working from the lightest to
the darkest tones of the
main subject.*

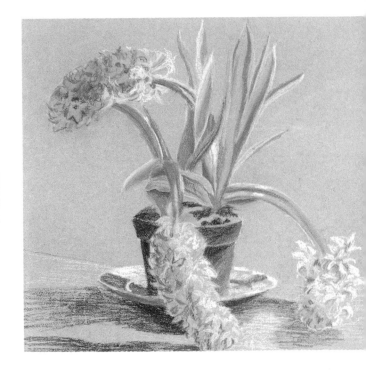

I began by putting in the lightest value, white, on the stalks and the flowers, then gradually working through the tones to the darkest. The paper colour was used positively as the shadow tone for the whitest blossoms and the lighter tone on the mid-toned flowers. As earlier, colours can be mixed by overlaying, and the order in which this is done can make a difference. On the pot, for example, putting down dark brown first and then feathering vermilion over the top created a much more homogeneous terracotta than applying brown over vermilion. Colours can be mixed by blending, as on the lighter green leaf. This softer technique also helped to show that this leaf was behind others. (See detail of colour mixing below.) I could have left the painting at this stage, using the paper as a background colour.

However, after recording the flowers I went on to pay attention to the background. Using a limited number of

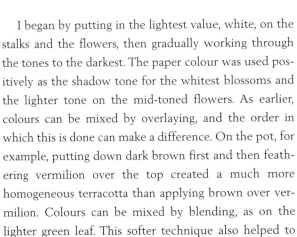

◀ DETAIL OF
COLOUR MIXING
*On the stalk the darker
green and white were
painted onto the paper first.
Each was modified by a
light feathering of strokes of
the yellow ochre. Violet
was used last both to 'grey'
the green and produce
darker shadow areas. The
pot colour was mixed with
two hues and I blended
three colours on the
background leaf.*

colours, I worked from a dark left-hand side to a light right-hand side of the picture. (I often light my paintings in this manner and wonder if it is a subconscious approach; the Latin for left is *sinistra*, from whence comes the English word 'sinister' with all its dark overtones!) The background was not entirely observed from life – in fact, in the studio the hyacinths were set against a jumble of a background – but partly from imagination, in order to reinforce the fact that the light came from a particular direction. I really enjoyed adding texture to the dark side by hatching with four colours: brown, orange, violet and green. Where it is darker the strokes are neater and more orderly. They fragment and become more random nearer to the light, thereby producing a

shimmering effect. The way I used the pastel on the background produced a contrast to the shaded manner in which it was used on the flowers. As I added the background I found I had to modify the lightness of the blended background leaf. I made it slightly darker, with an overlay of light violet so it did not leap forward too strongly. When working on a painting this process of modification goes on all the time, and with pastel it is not too difficult.

HYACINTHS
Pastel, 13½x15½(35x40cm)
The addition of the background emphasized the lighting in this painting.

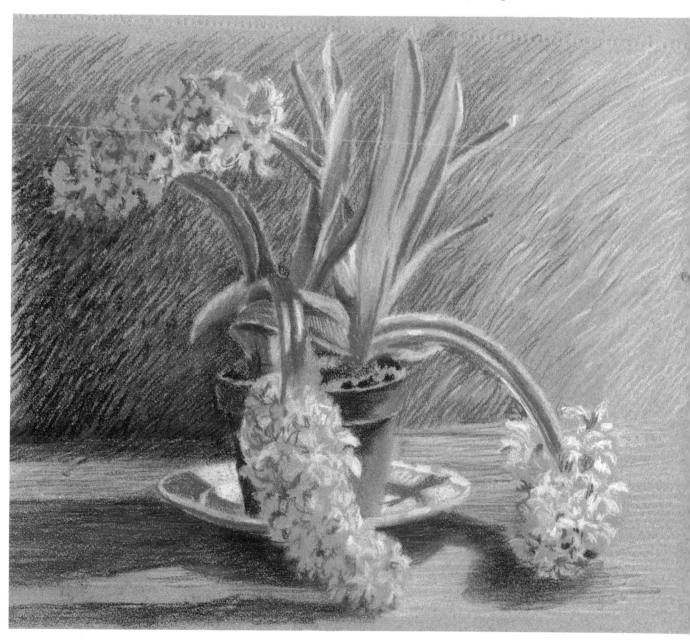

PAINTING FLOWERS IN PASTEL

As with watercolour, you will modify your approach to the subject depending on what you wish to communicate. If, for example, you want to record a whole garden full of flowers you will paint an 'impression' of the scene rather than a literal, botanically accurate description; but once again, the trick of capturing a few unique details that make a plant recognizable is useful. Seize upon a characteristic and repeat it freely. In this pastel *Francis' house, Langwell* I hope that horticulturalists will be able to identify round-headed echinops and the artistic complementary coupling of eupatorium and rudbeckia! The detail of the foliage is not minutely recorded, but any slight colour bias in the greens has been enhanced so as

to differentiate between them. The foreground is strongly worked with the darkest values and I have used a more linear approach – harder Conté pastels achieve the thinner lines. The planting in the left-hand border fades away into less distinct mounds of softer blended colour, not unlike the watercolour painting of the same garden.

The study *Iris* illustrates an entirely different approach. The flower took my breath away, it was so delicate and papery, and the gleaming highlights enhanced

▼ *FRANCIS' HOUSE, LANGWELL*
Pastel, 16¼x18¾in (42x48cm)
Herbaceous echinops, eupatorium, rudbeckia, filipendula, tritonia... this has to be a gardener's house!

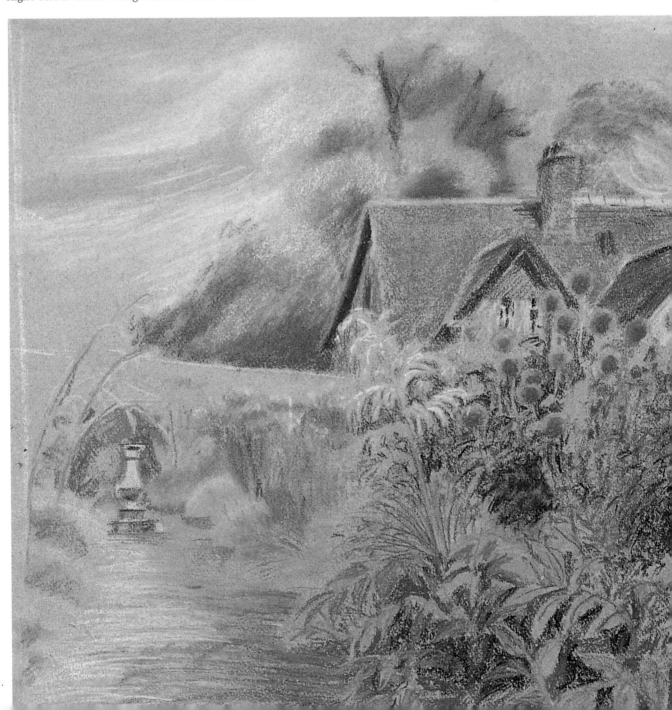

its beautiful blue hue. I immediately chose a pale grey-blue tinted paper to link with its colour, and no painted background to distract the eye. The flower seemed to compose itself on the paper. Amazingly I used quite fat Unison pastels to capture the detail. When needed, I cut chips off the sticks. Concentration was intense – it was like doing two hours of yoga! After fixing, the highlights were polished up with pure white.

The unfinished *Study of peony and penstemon* (below) shows that the addition of a darker background will dramatize the flowers. At present the greens are not subtle or 'greyed' enough. I will also obliterate the white lines that I have used to outline the flowers in the finished painting, which are rather distracting.

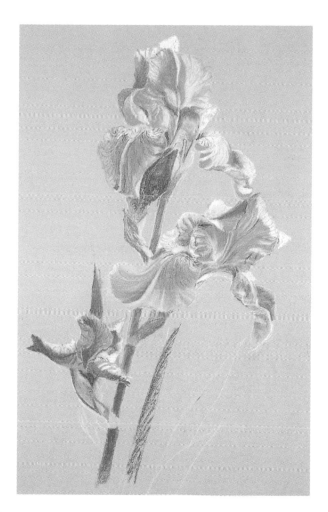

▶ *IRIS*
Pastel, 15½x12in
(40x30cm)

▼ *STUDY OF PEONY*
AND PENSTEMON
Pastel, 13½x19in
(35x49cm)

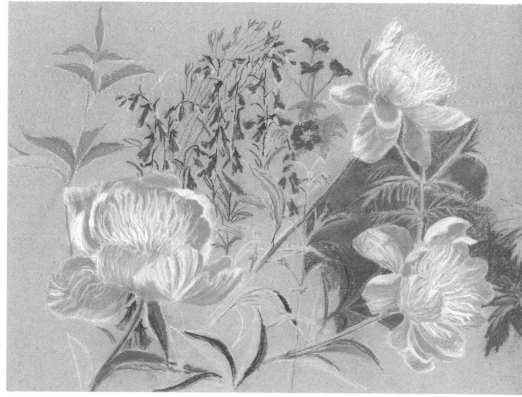

chapter nine

CREATING MOOD IN
A PAINTING

Every painting you do has the potential to convey more than just how 'real' things look. As I said at the beginning of the book, painting can be a kind of poetry, appealing to our emotions, evoking a mood. I wanted the pastel painting *The topiary garden, dusk*, to invoke a feeling of solidity and immutability, probably the last thing you would expect from a garden. To this end I rendered all the foreground in a very meticulous

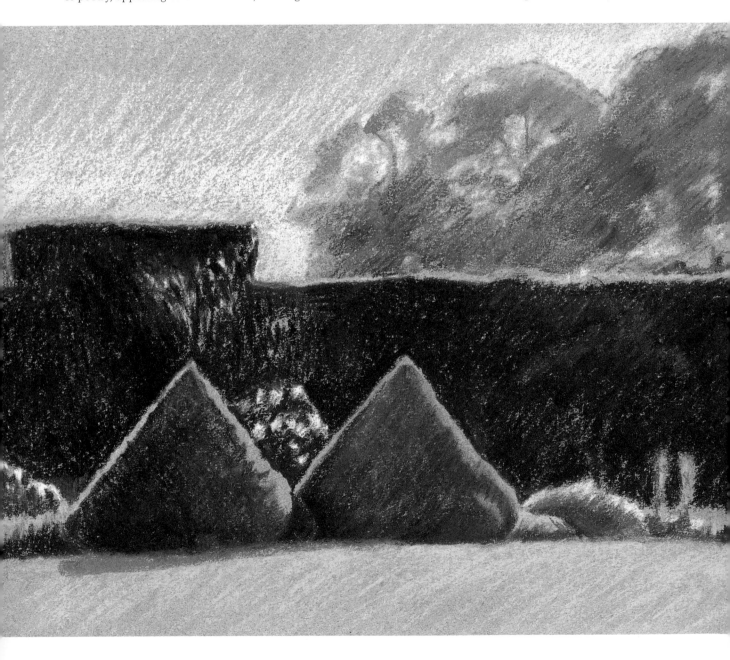

style. The edge treatment was discussed on page 108. There is an air of slight melancholia about the painting with its dying light, and this is conveyed by the relationship of the light and dark tones and the controlled range of colours.

I have already talked about 'tonal key' which is the range of tones used within a painting. In a low-key painting the light-value areas will be few or non-existent, drawing tones from the darker end of the scale. Tonally, high-key paintings will contain generally light values and colours. Compare, for example, *The topiary garden, dusk* with *Flowers in a landscape* (pages 124–5). The hues in both are not dissimilar, but the fact that the latter draws its range of tones from the lighter end of the scale gives

a feeling of sunlight. You can manipulate the tonal key to enhance the mood of a painting.

Paintings can also be worked in high-key or low-key colour. The former is intense, saturated colour that gives a feeling of strong light, the latter is subtle and greyed and will help to produce muted atmospheres. *Mary's flowers* (page 122) are painted with a high-key approach,

THE TOPIARY GARDEN, DUSK
Pastel, 9x20¼in (23x52cm)
The background trees are rendered in loose hatching, in contrast to the closely worked hedge and bushes; their colour is cooler and their tone lighter – all devices which help the feeling of recession.

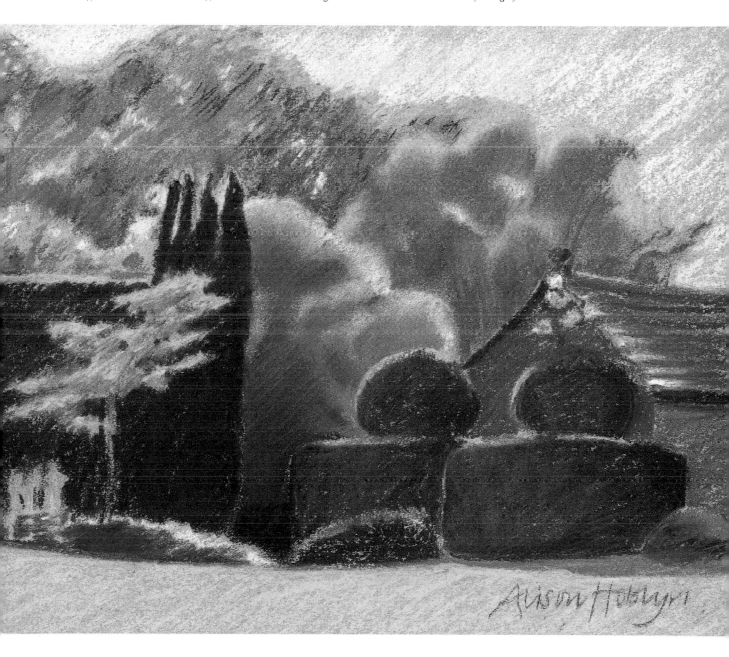

*DELPHINIUMS AND
IRIS
Watercolour, 26x26in
(67x67cm)
Although the subject matter
is complex, the restricted
palette helps to unify
the painting.*

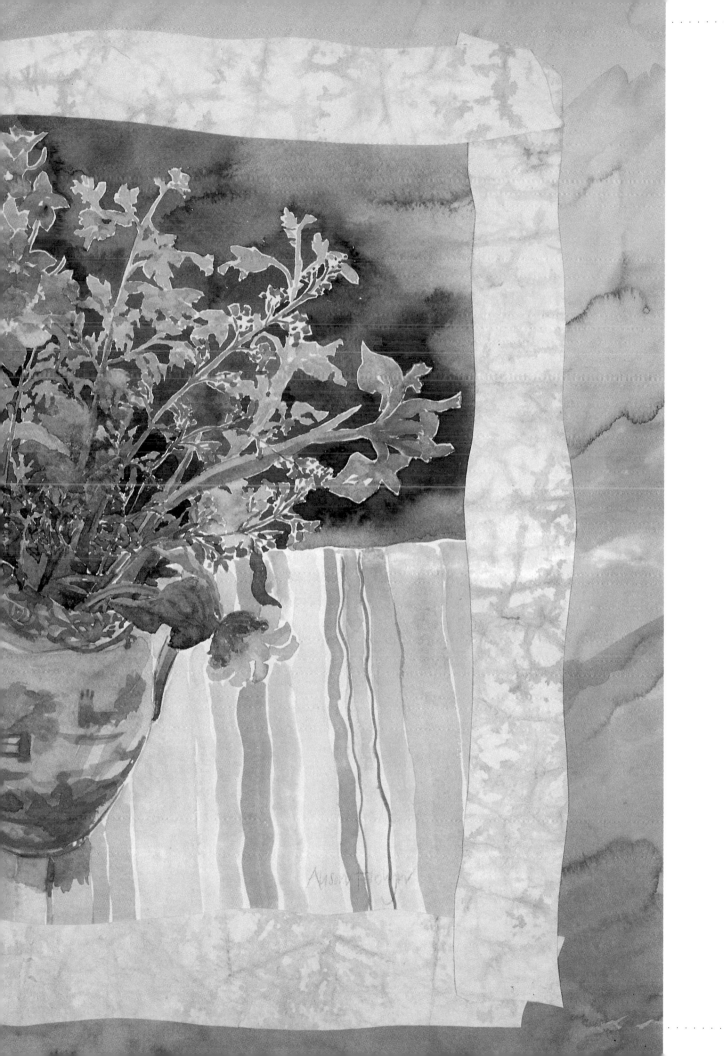

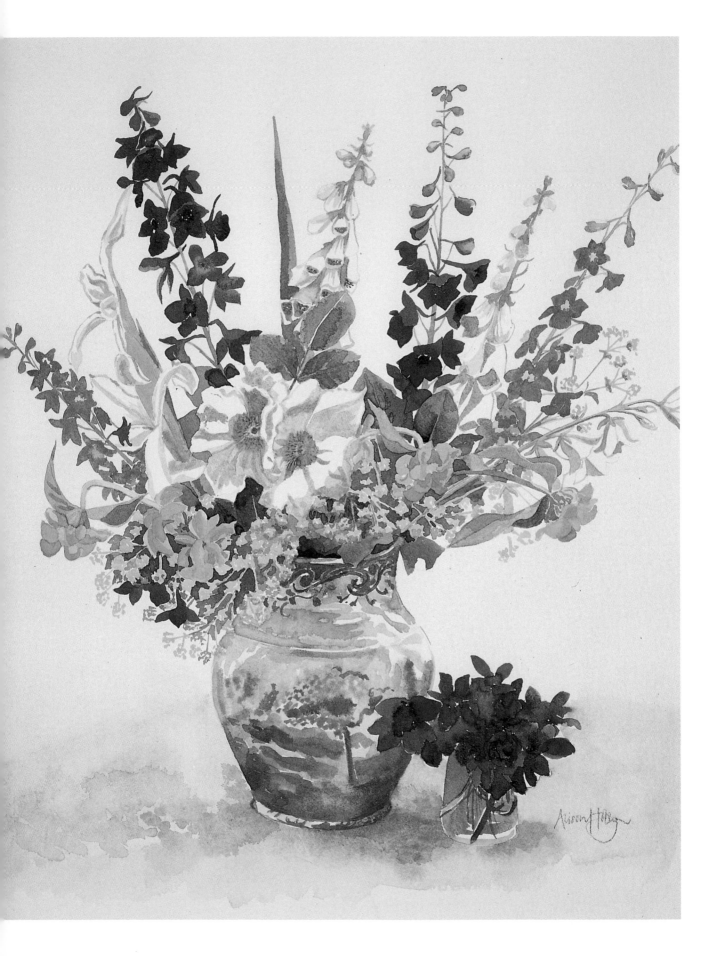

whilst the palette of *The garden wall, Lybster* is suitably low key to mirror the dying light of the subject.

I wanted a peaceful mood for the painting of *Flowers in a landscape*. To this end the composition was horizontal, and it was also divided horizontally by table, wall, hedges and fields. The shapes were made up of softly modulated curves. The tonal range is high key, the colours neutral in temperature, with some warmer areas to convey mellow sunlight. The arrangement of the foreground flowers is uncluttered, allowing the eye to study them easily.

◄ MARY'S FLOWERS
Watercolour, 22½x18in (58x46cm)
In this painting I concentrated on the detail in the flowers – the overblown Rosa 'Blanc Double de Coubert' contrasted well with the structured shape of the phlomis. I wanted no background to distract.

▼ THE GARDEN WALL, LYBSTER
Pastel, 8½x16in (22x41cm)
Although to call this a painting of a garden may be tenuous, the presence of the garden wall was important to underline the scale of the landscape. As in Corsican cistus, *page 93, and* Flag iris; Lumio, Corsica, *pages 40–1, I like contrasting the small-scale beauty of the flowers with dramatic scenery.*

By contrast, the painting *Delphiniums and iris* (pages 120–1) was all about the dynamics of growth. I adopted a high viewpoint so that I was looking down slightly on the subject, and this put the focus on the flowers and foliage. These are crammed into the vase, their diagonals contrasting effectively with the verticals of the picture and the lines on the cloth. They also stand out strongly against the dark-toned background. The organic borders allow the composition to carry on 'growing'. Although the colour choices in this painting are very similar to *Flowers in a landscape*, the composition and tonal range evoke a much livelier mood.

Look through the paintings in the book and if any one conveys a particular mood see if you can analyse why. The temperature of colours can also affect our feelings; look at the warmer palettes used on the cottage in *Topiary bird* (pages 70–1), *The Granary window* (page 103) and *Nasturtiums and pansies* (page 15).

I think it is a painter's duty to try to convey feelings however you achieve it!

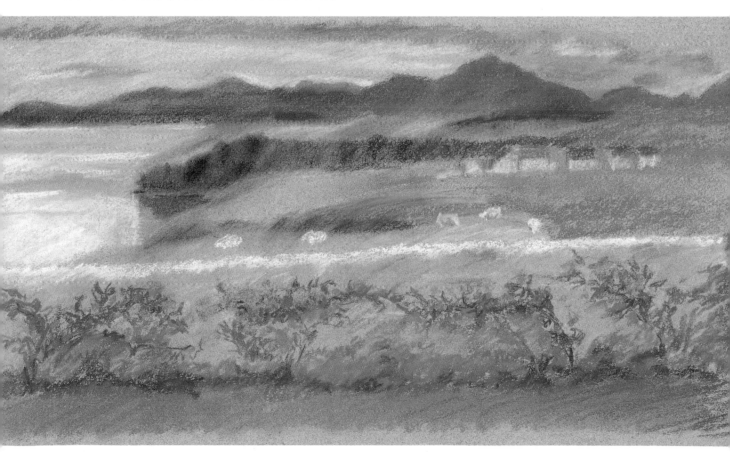

FLOWERS IN A
LANDSCAPE
Pastel, 24x16¾in
(61x43cm)
The stylized circular shapes
of the background trees and
hedges echo the curves of
jugs and flowers. Using this
stylistic approach helped
me convey a tranquil and
ordered landscape of almost
domestic scale.

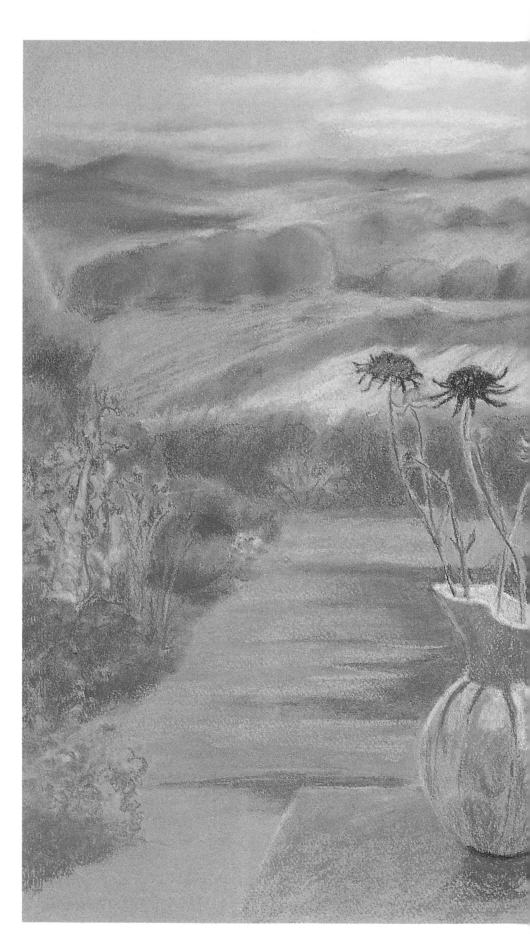

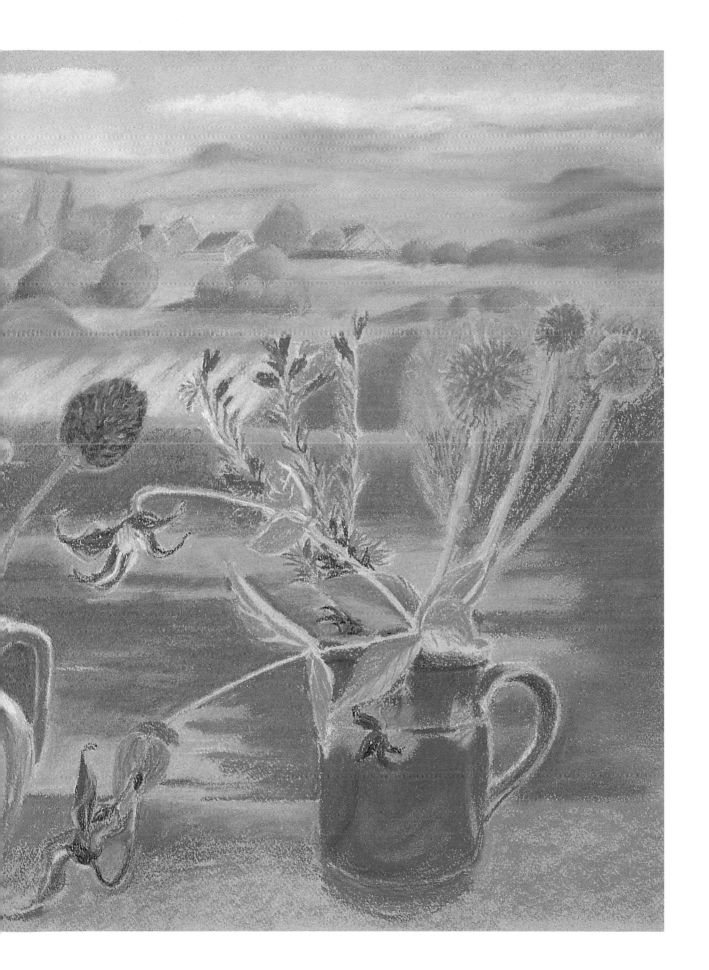

CONCLUSION

Although this book has covered many techniques I would hope that you will not follow any of them too slavishly. View them as rules to be broken! Your aim should be to produce a personal vision on paper, using your own, naturally developing style.

Painting gives us another route to engaging with the world, different again from the logical and verbal paths that we normally follow. In the words of the painter Cecil Collins (1908–1989) 'Painting is the language of sensation, words the language of thought'.

I simply wish that you may have been inspired to try some of the ideas for yourself. And it is to be hoped that in this way, you will go out and be able to respond to a grand garden or a modest flower with more insight and more pleasure than you have before. Painting is like the gate in the garden wall: an entrance to a different view on life. According to Picasso, 'Art is a lie which makes us see the truth'.

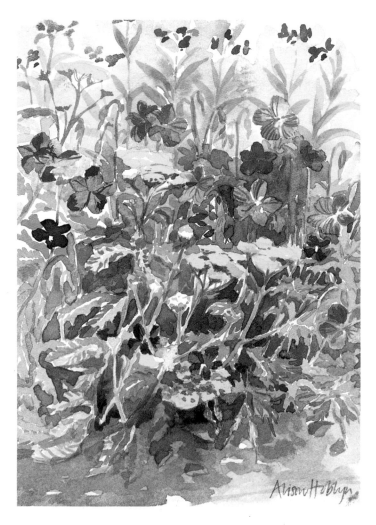

ACHILLEA AND GERANIUM
Watercolour, 8x5¾in (21x15cm)

INDEX

ACKNOWLEDGEMENTS

Thanks go to:
All my family – especially David, Sarah and Louise – for forbearance and support.
Alison Elks for vision.
Kate Yeates, Brenda Morrison and Freya Dangerfield at David & Charles – for holding my hand.
The owners of paintings, particularly Michael and Jenny Hinton, Jane Cairns and Mary Colson, for enduring forced absences from their pictures.
Hugh Palmer for the kickstart.
Marie O'Hara for encouragement.
Emma Bradford and Neil Philip for sharing their experience.
Emma Pearce at Winsor and Newton for technical advice.
Kate Hersey at Unison Pastels for generosity.
The Dark Room, Cheltenham for professional trannies and a sense of humour.
Pat, Helen, D and Linda, four stalwart students.
And finally all the creators of the gardens – too numerous to mention – for inspiring me.